Random Imaginations

A Collection of Illustrated Musings

By Eddie Chau

ORO
EDITIONS

For all students—past, present, and future.
And of course, Mom and Dad.

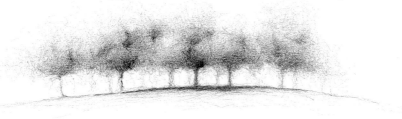

The strength of the 'big idea' is born from lots of tiny imaginations.

Introduction

I never set out to publish a book. I never set out to draw thousands of tiny images in a single sketchbook, yet in doing something I enjoyed, an unexpected book transpired.

In an attempt to break out of a design block one evening during my landscape architecture graduate studies at Berkeley, I began drawing a series of thumbnail sketches on a single page. This eventually avalanched into a sketchbook of over 5,000 tiny freehand drawings, completed over the course of 27 years, most of which are reproduced here.

Like many people, I tended to draw what I saw in front of me. Wanting to challenge this approach, I drew these little sketches of everyday objects, abstracts, and landscapes entirely from remembrance and imagination. There is no rhyme, reason, or organization to the drawings, other than recording a stream of consciousness and bringing it to life. The recollection of unique features of special places I've traveled, along with the appreciation of the beauty and utilitarian design of ordinary objects, inspired me to look at my surroundings everyday for small details and forms, and interpret them on paper.

The sketchbook eventually became a visual catalog by my desk, sort of a reference book, to pick up, draw in, and peruse whenever brushes of difficulty or inspiration came upon me. Each 1 ¼ inch square became windows to architectural interiors, horizons, household items, patterns and shapes, compositions, outdoor spaces, stories, and images I can't explain.

With my trusted Pelikan, Mont Blanc, and Pilot Falcon fountain pens and ink, these imaginations came into being and reinforced my belief in my ability to daydream for long stretches. What began as a bout of frustration, eventually became a joyful visual journey of personal creativity I never expected.

—E.C.

Preceding page: Tree Grove *Silverpoint on illustration board*

Foreword

By Christopher Grubbs

When most people want to go somewhere else, they think of walking, riding a bicycle, or taking an airplane. Drawing is Eddie Chau's mode of transportation. Eddie observes life, remembers what he sees and feels, and in no particular order through the years, draws vestiges of that experience onto the page.

Random Imaginations is not so much a book as a mind-bending tour of his own interior self. Each wonderfully varied image is like a window through which you can glimpse a piece of some potentially intriguing story. I feel as if I could actually walk through each window and see its whole story revealed, in the form of a novel perhaps, an epic poem, an entire universe.

Some subjects he draws seem pedestrian. Some drawings are quite mystical. What images he draws and why he draws them, may be a mystery to him. Whatever he calls up for himself is a simple piece, a little snippet of observation and memory, drawn up especially for a subconscious special occasion.

And he invites us to come along for a joyful ride.

Christopher Grubbs is an illustrator, design consultant, artist, and lecturer on drawing as an aid to the design process. He has worked on the Martin Luther King Jr. Memorial in Washington D.C., the National September 11 Memorial, the Museum Landscape Plan in New York City, and has established an archive at the Library of Congress.

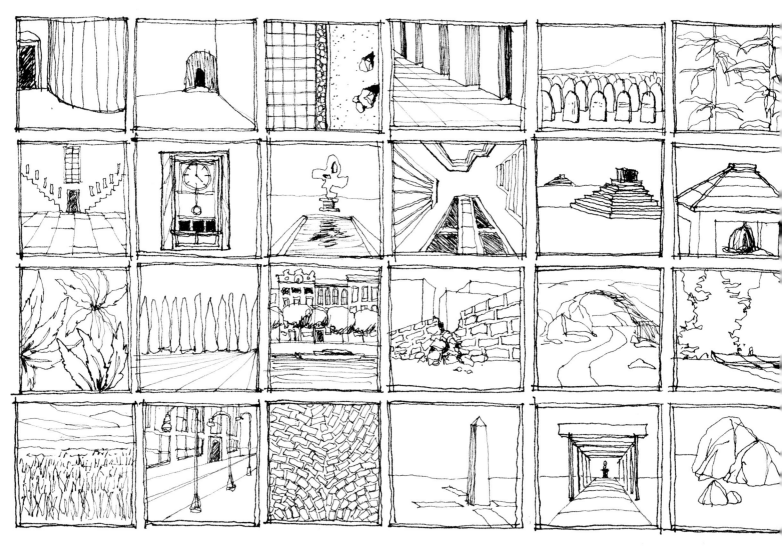

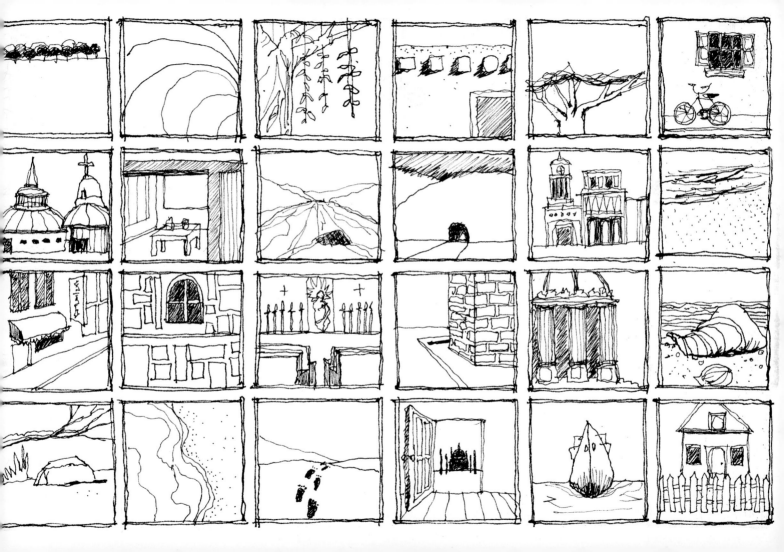

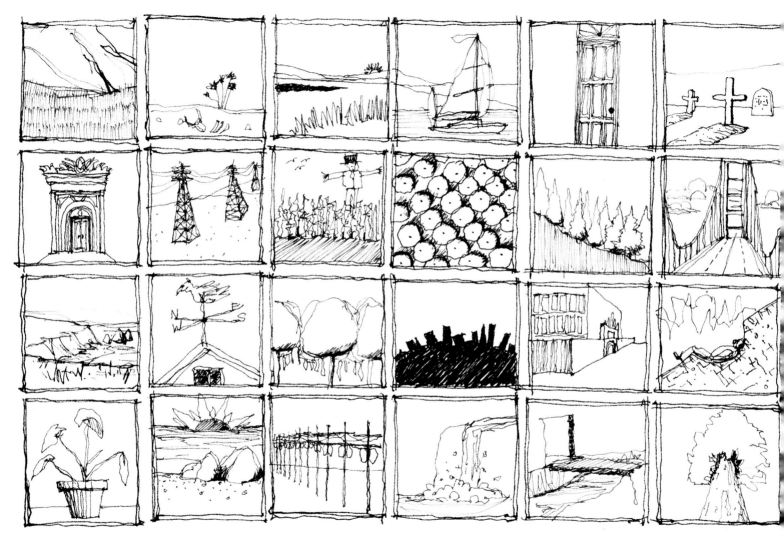

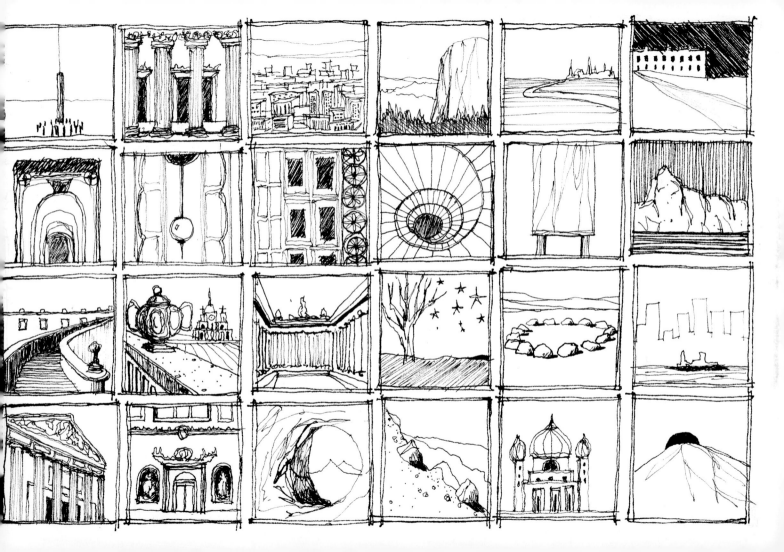

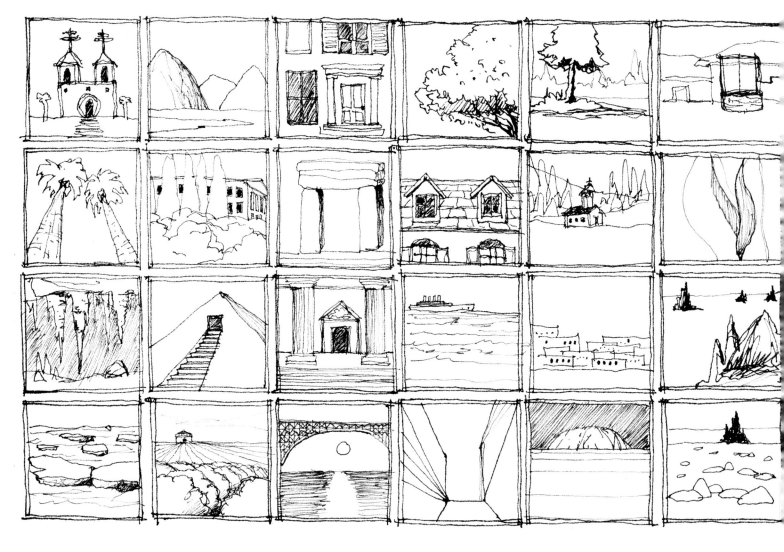

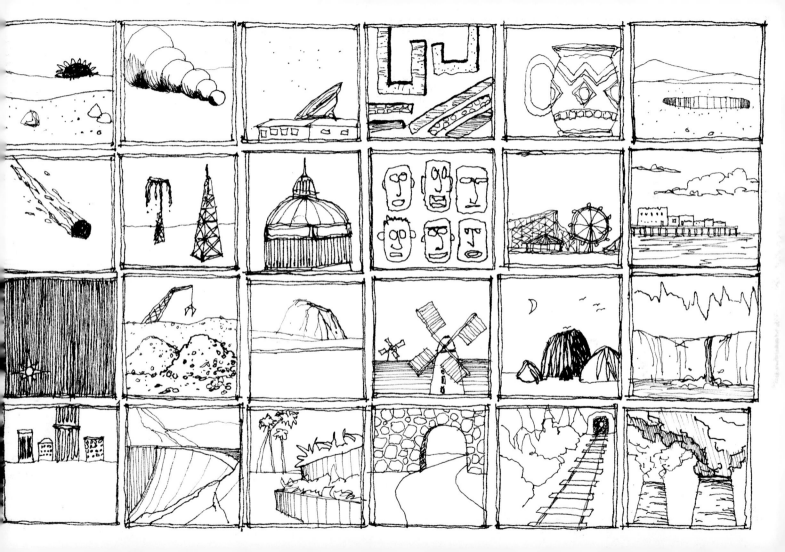

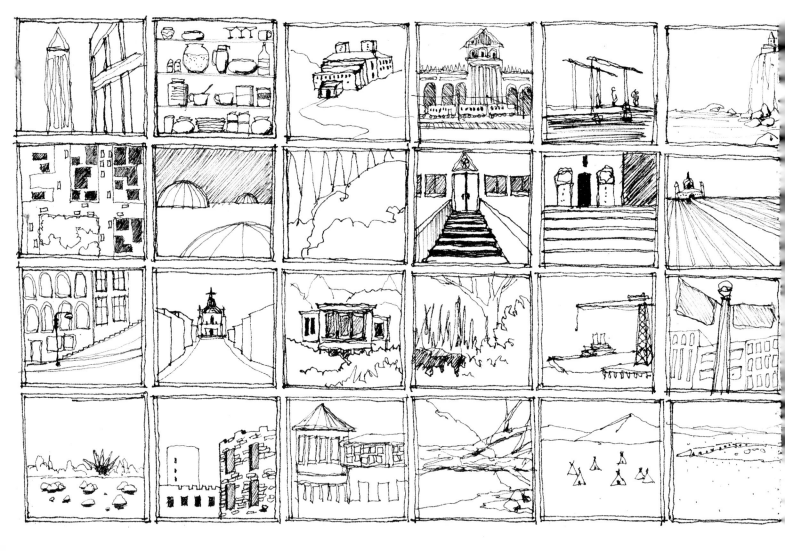

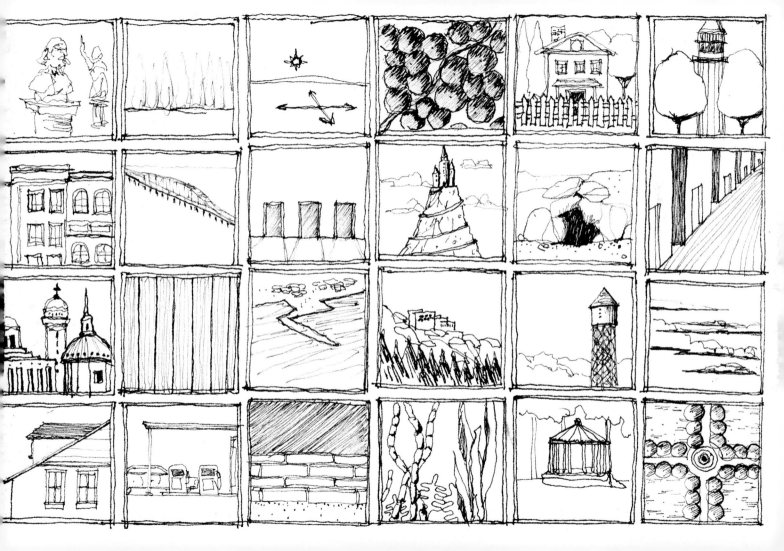

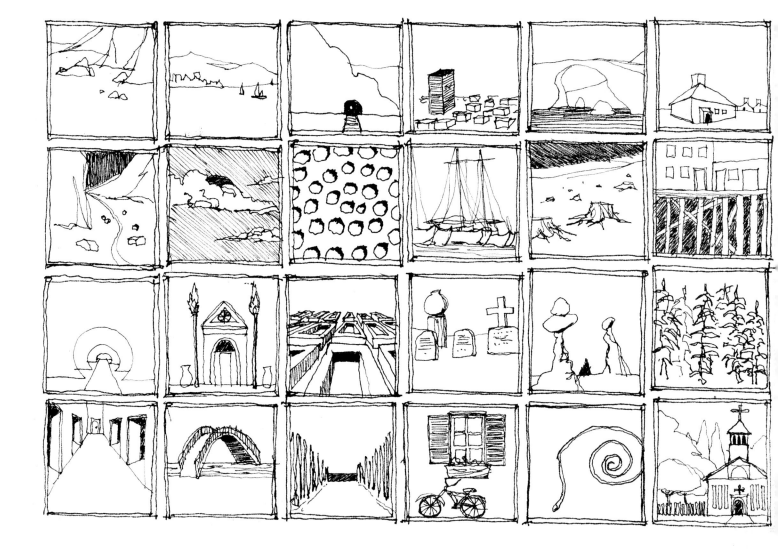

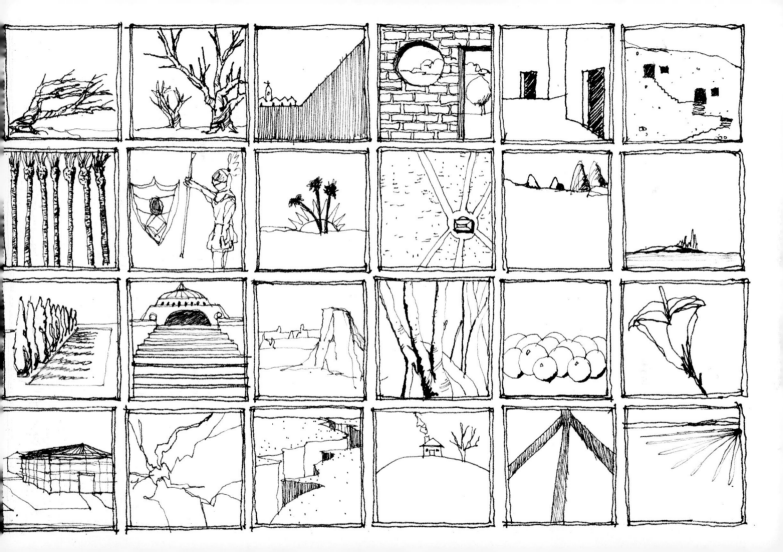

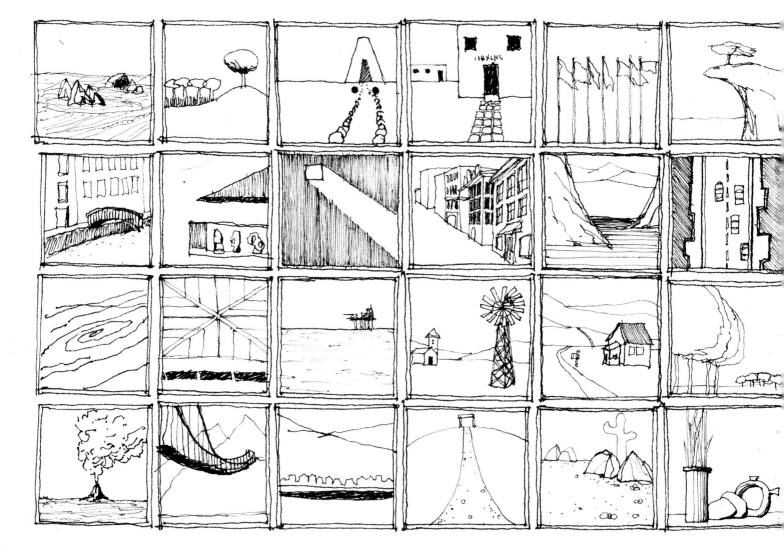

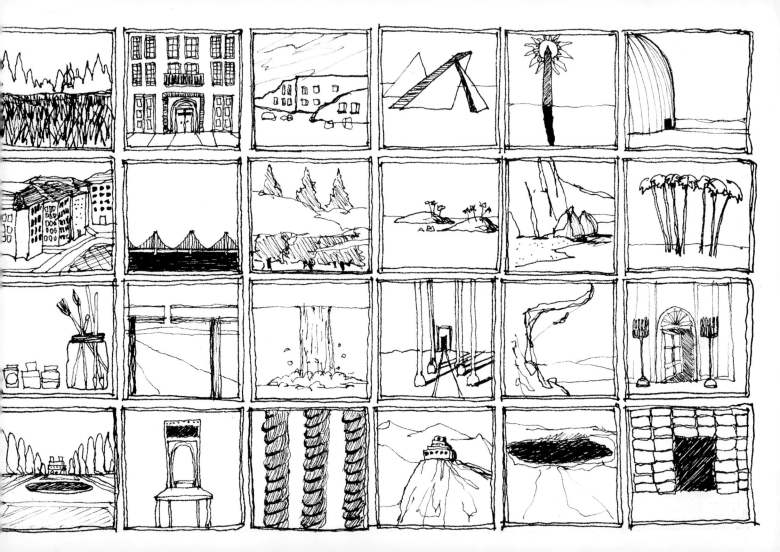

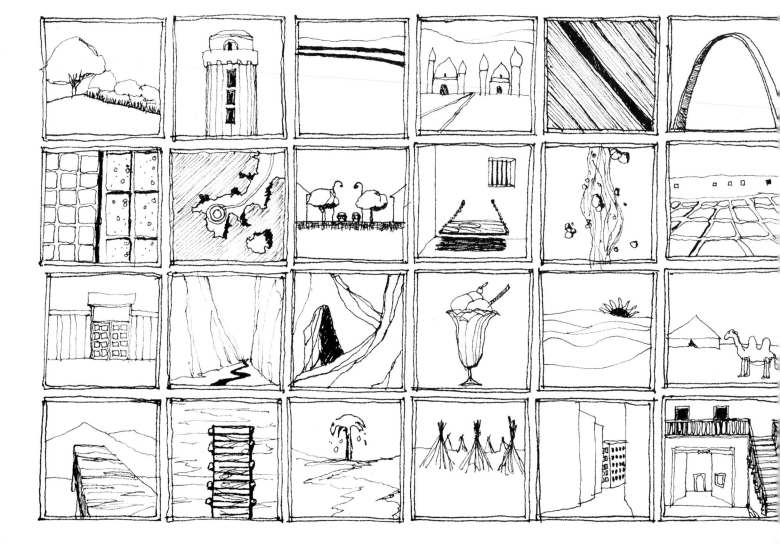

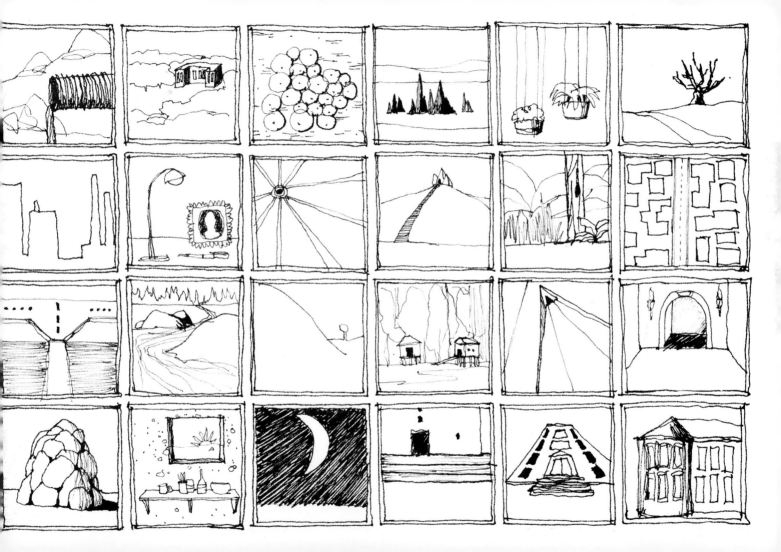

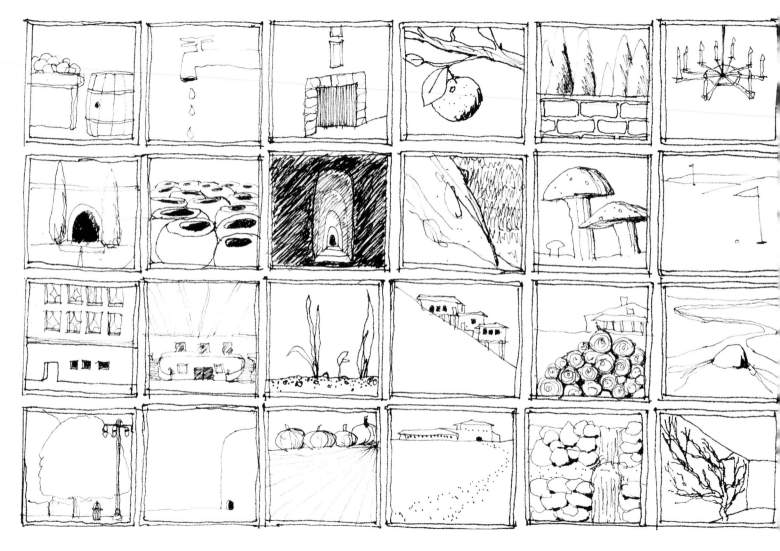

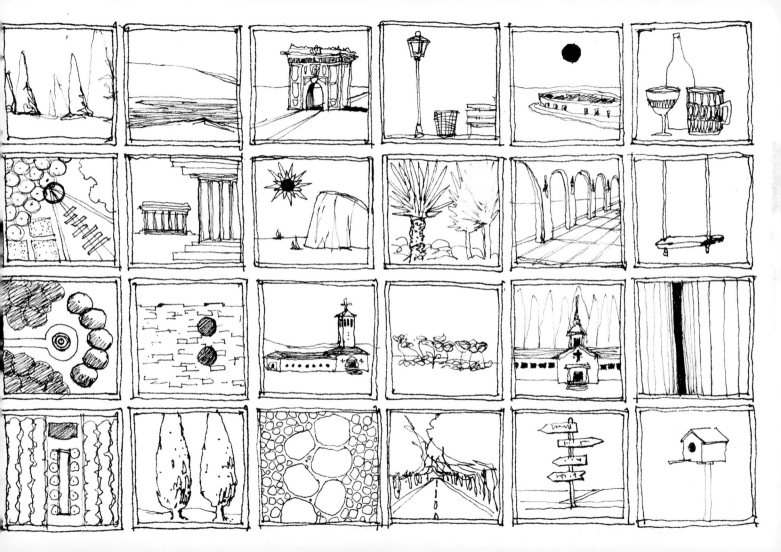

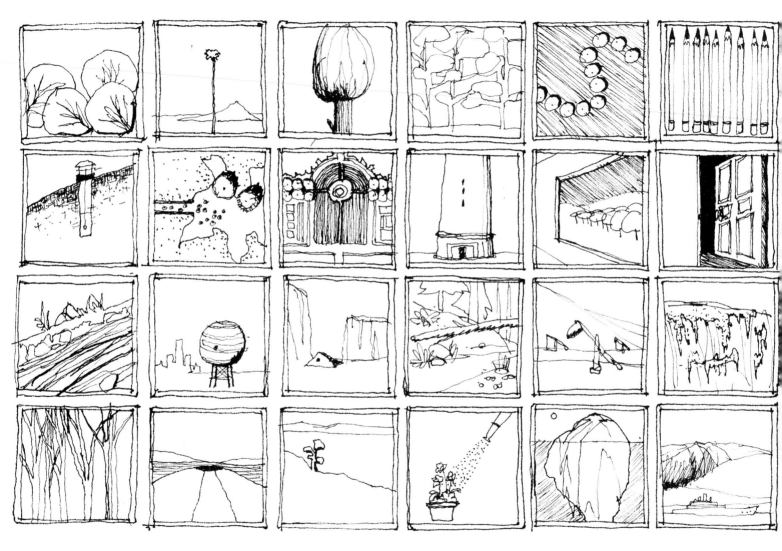

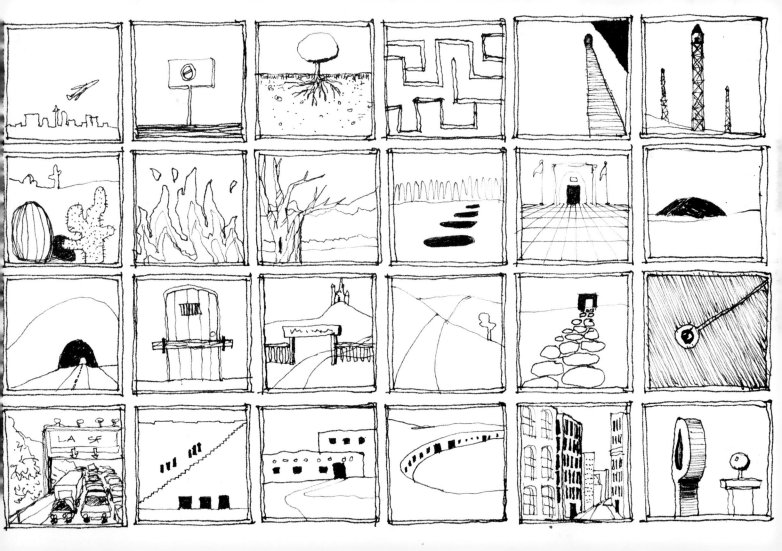

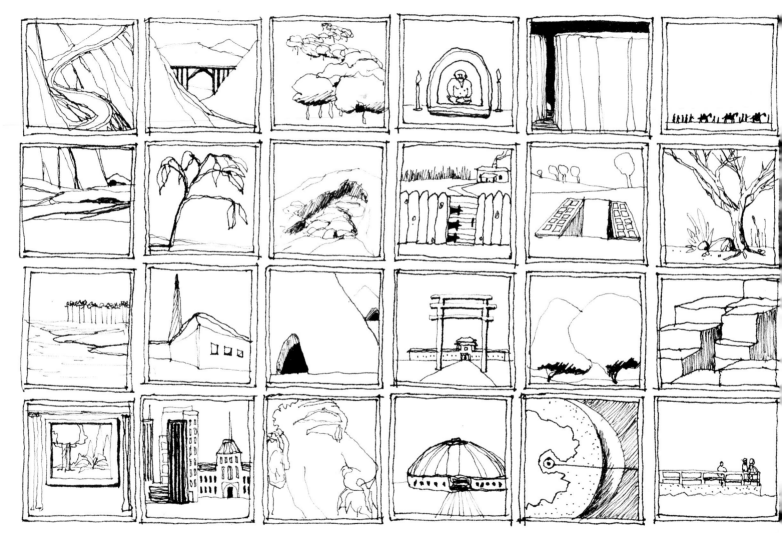

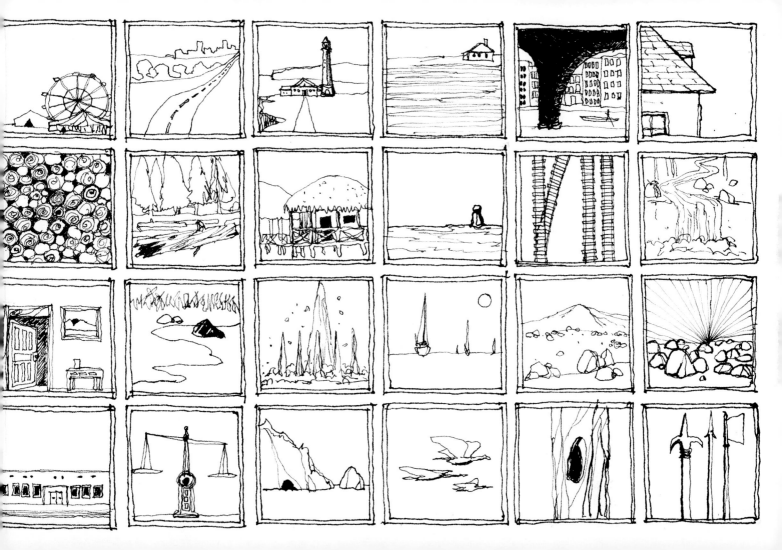

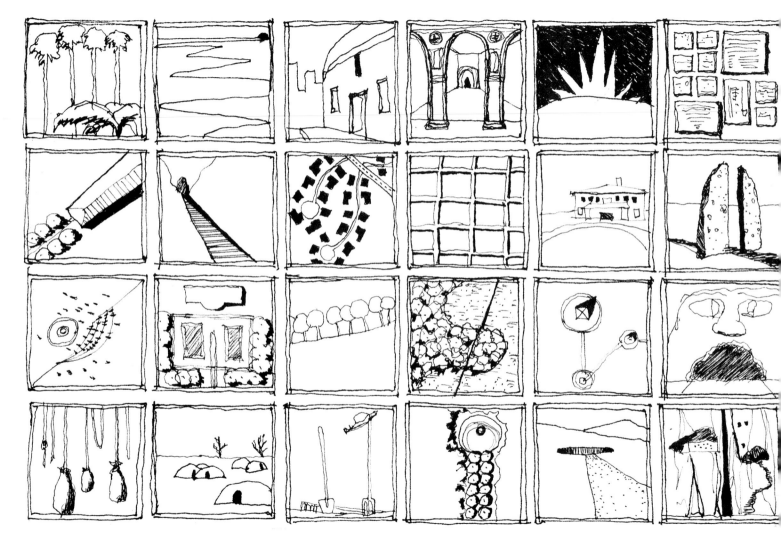

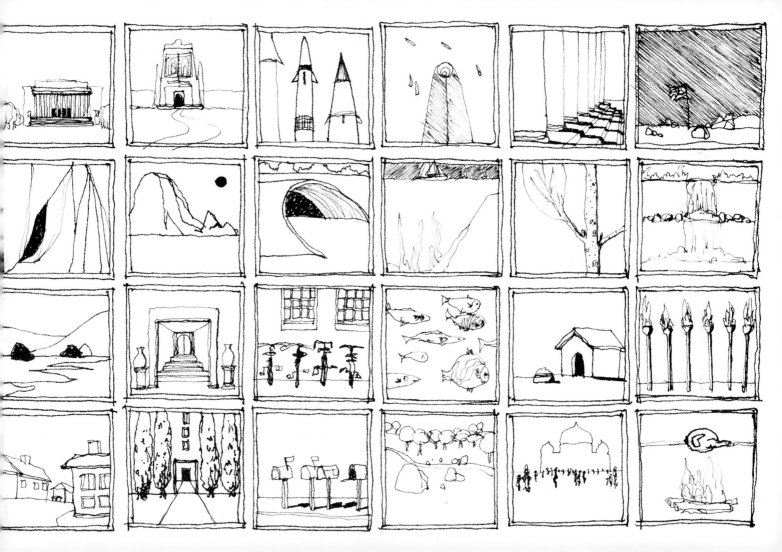

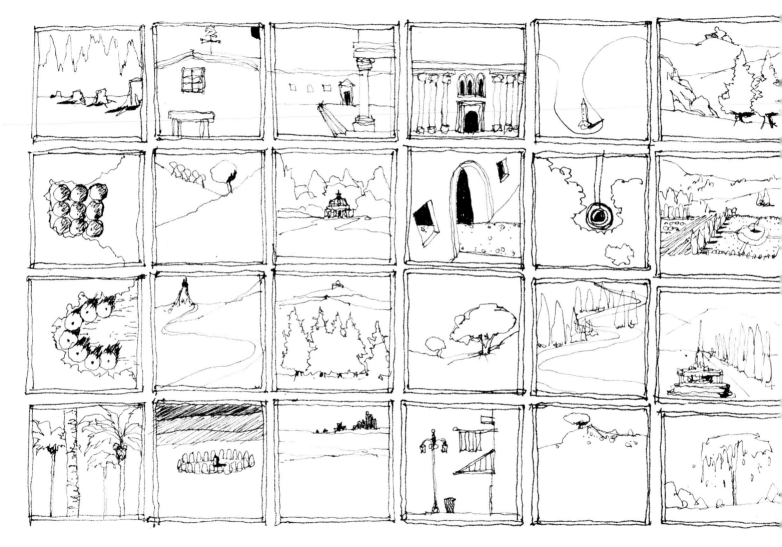

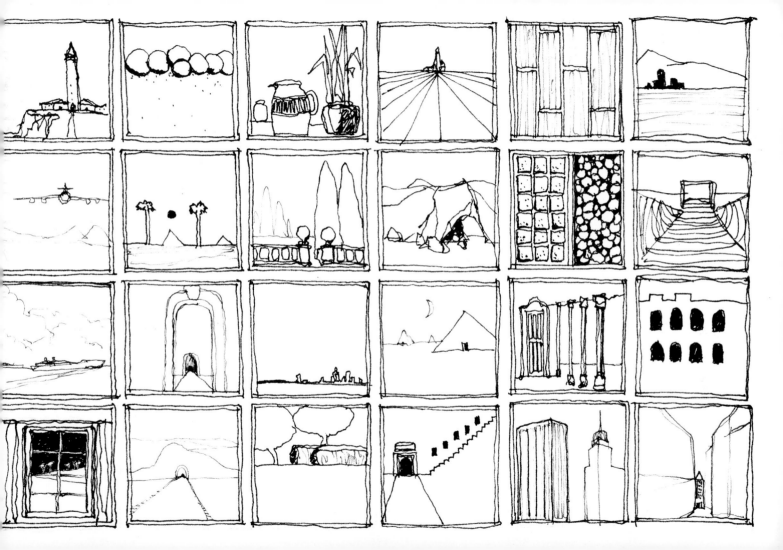

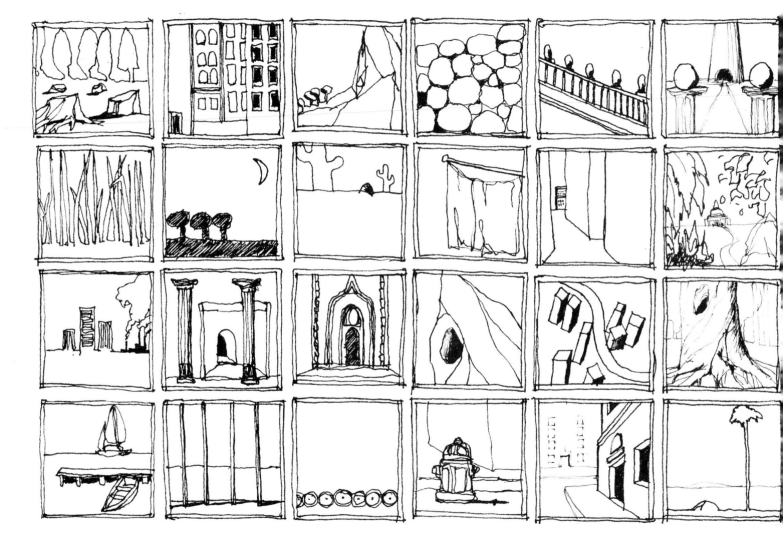

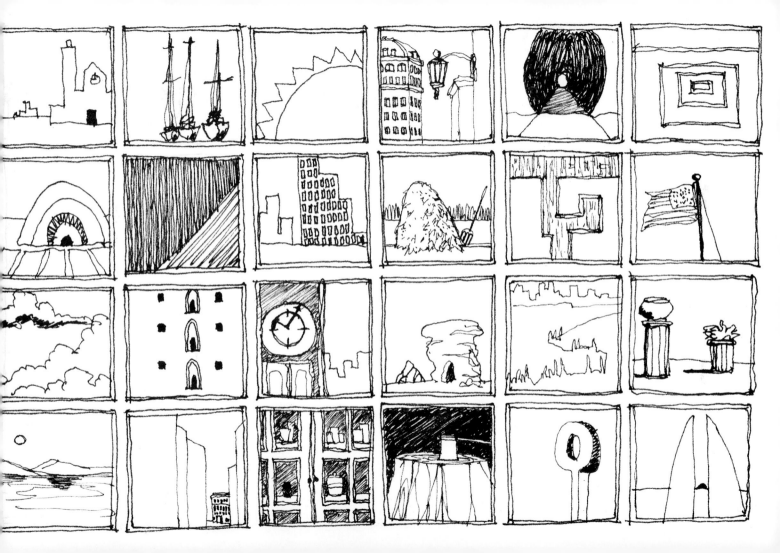

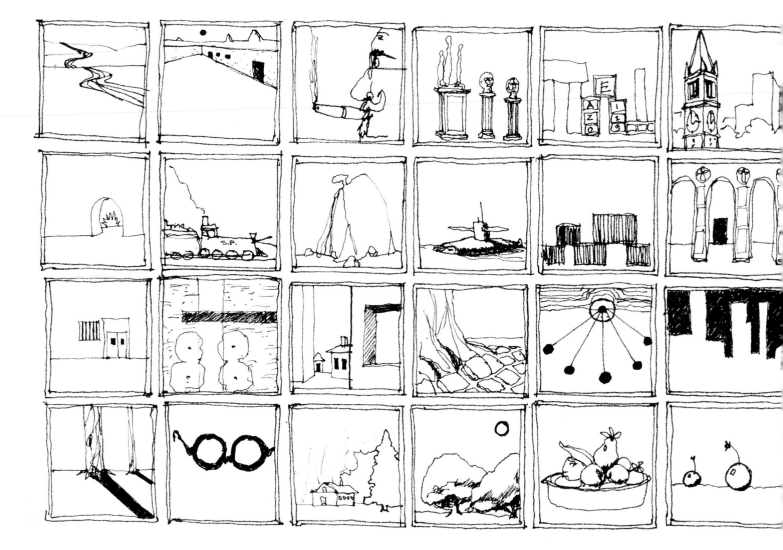

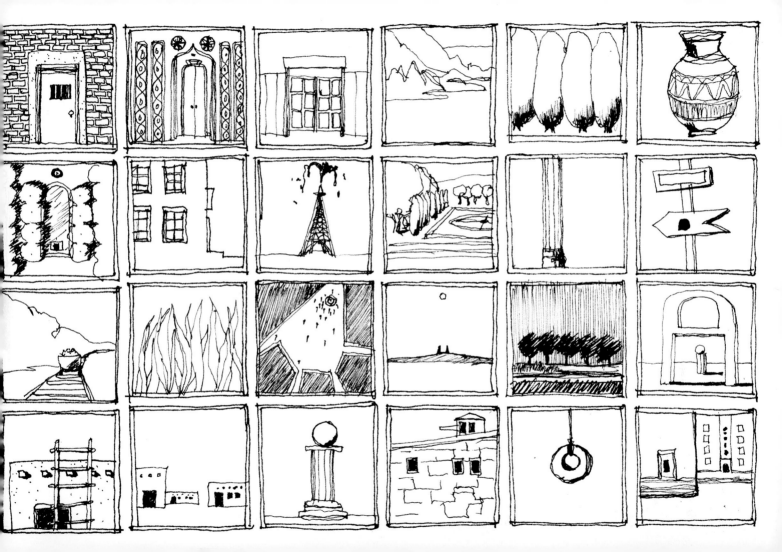

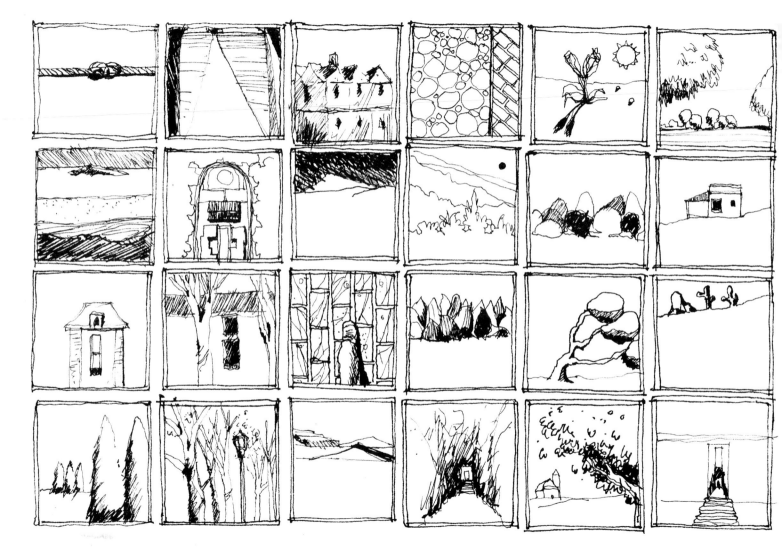

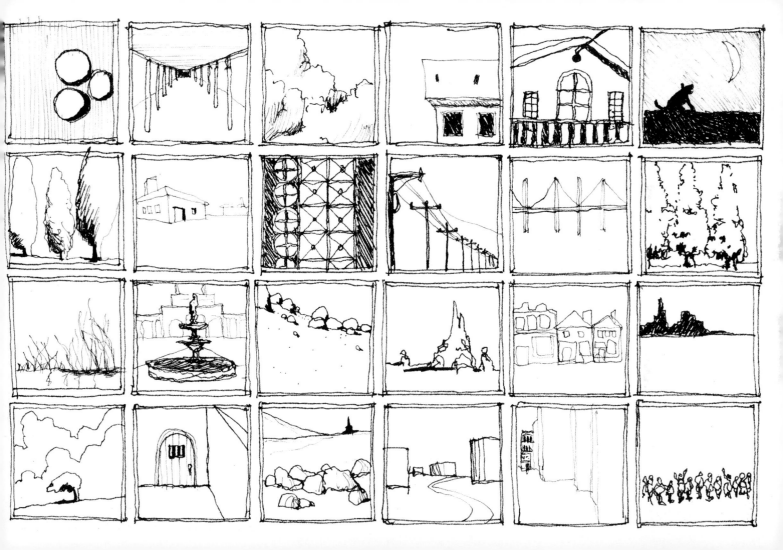

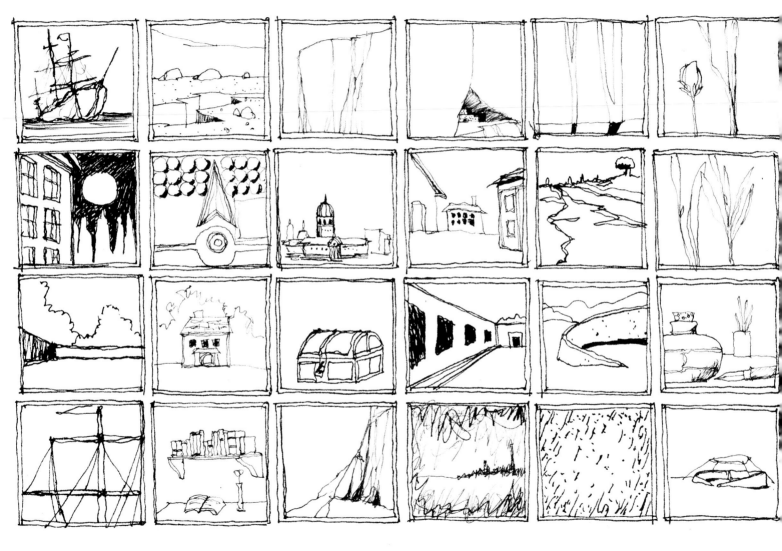

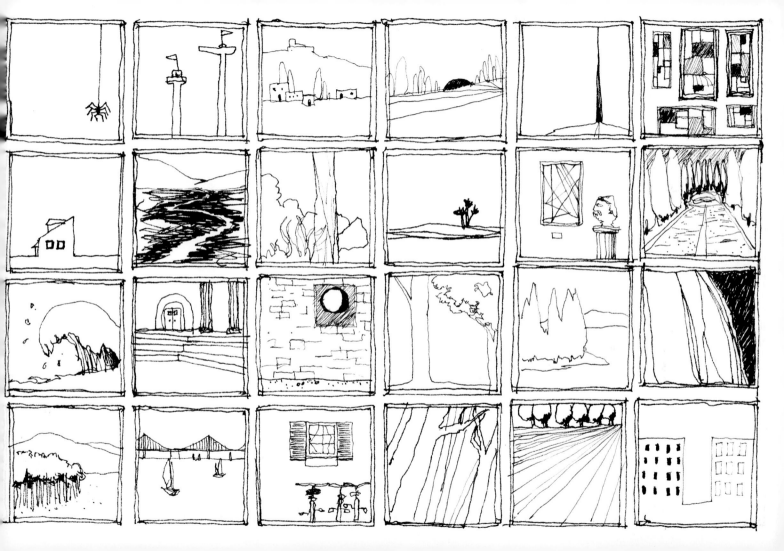

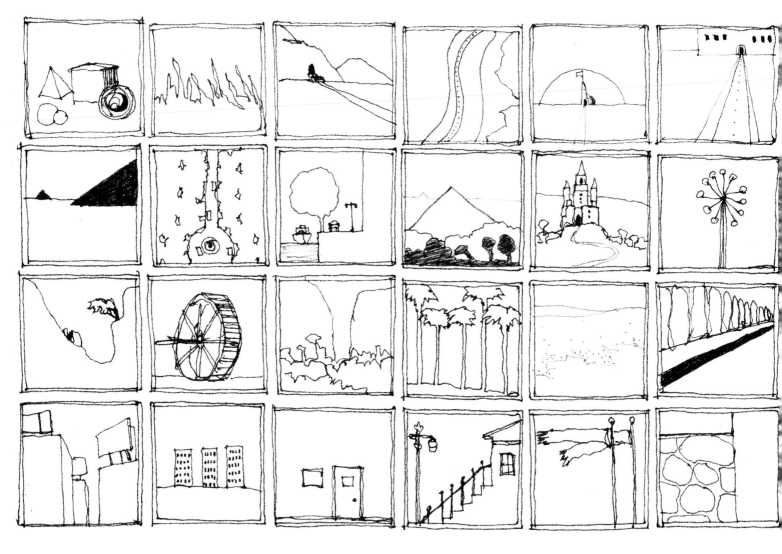

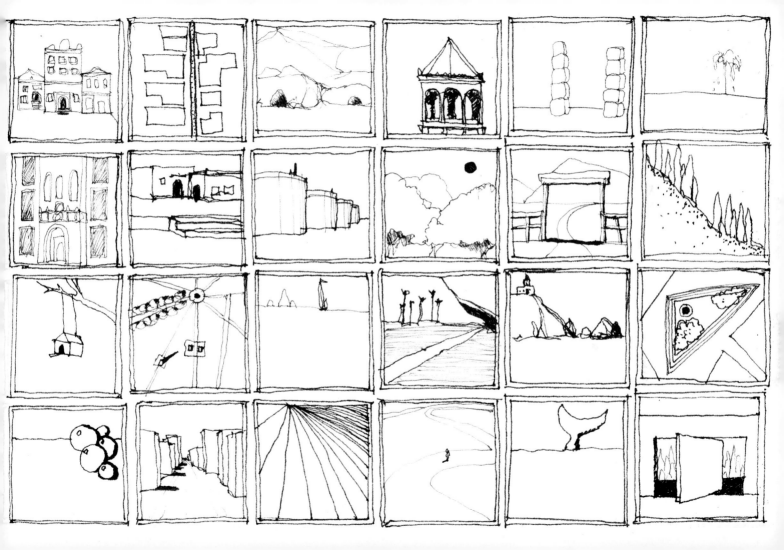

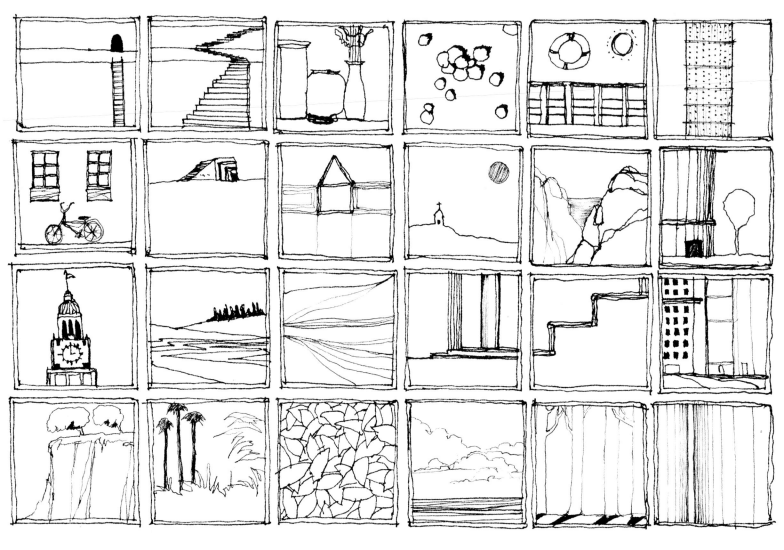

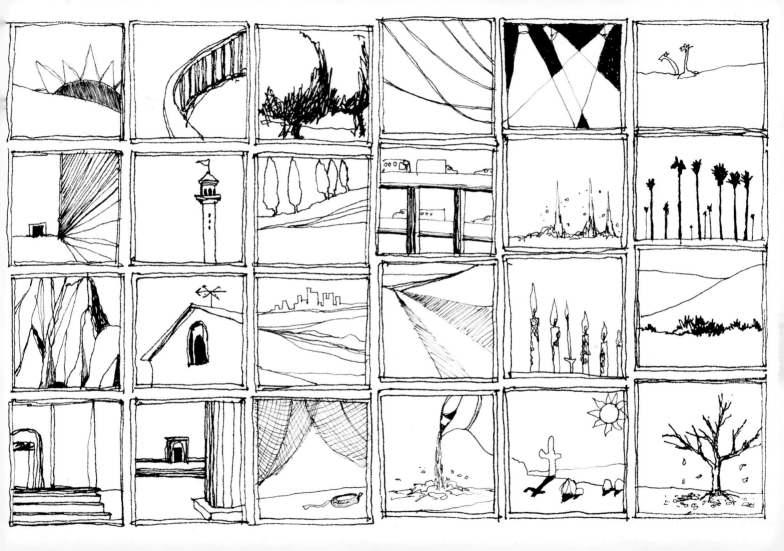

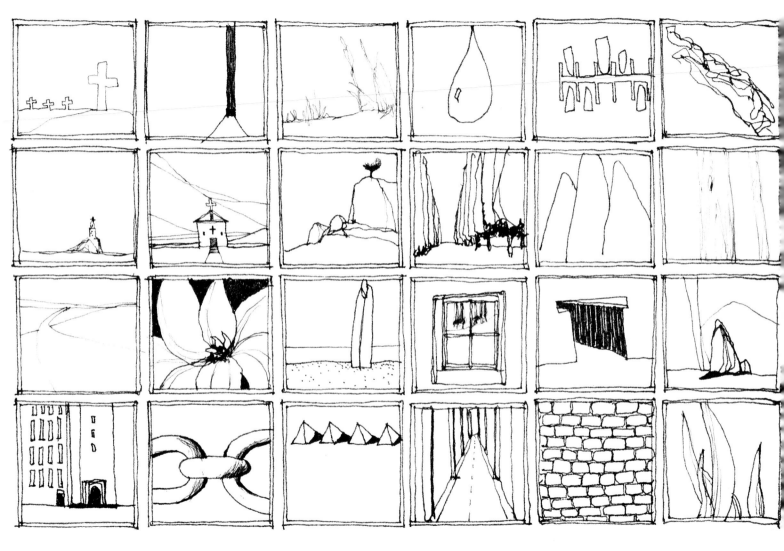

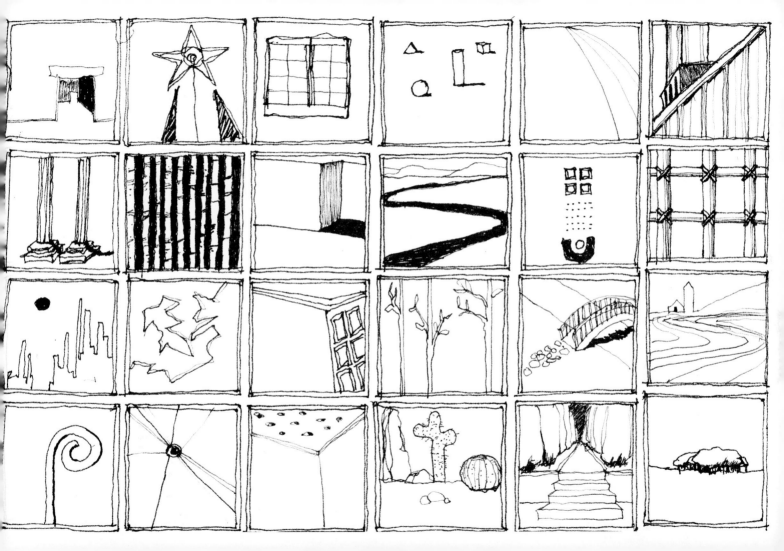

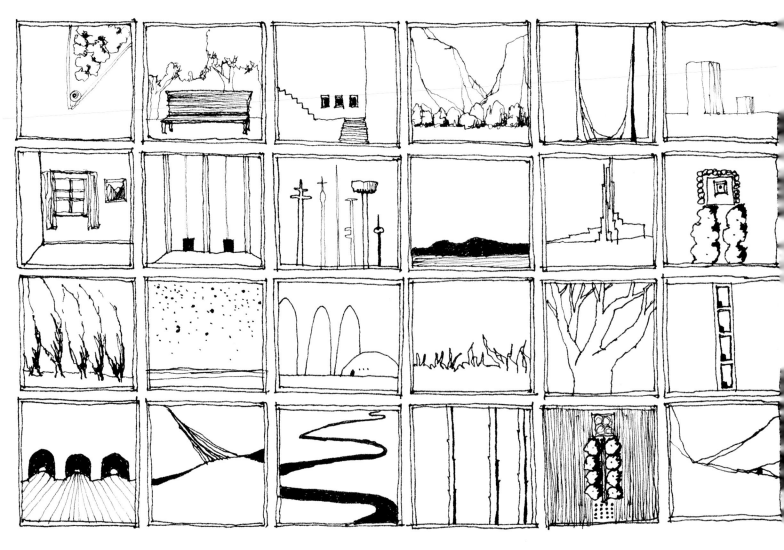

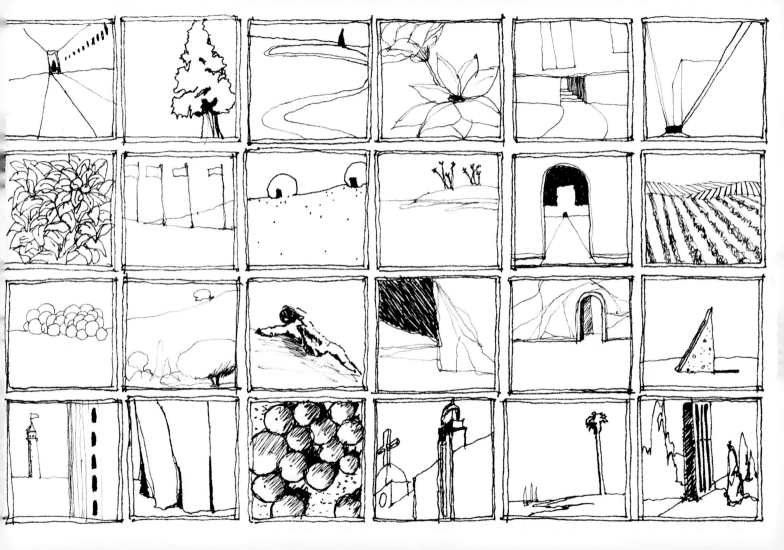

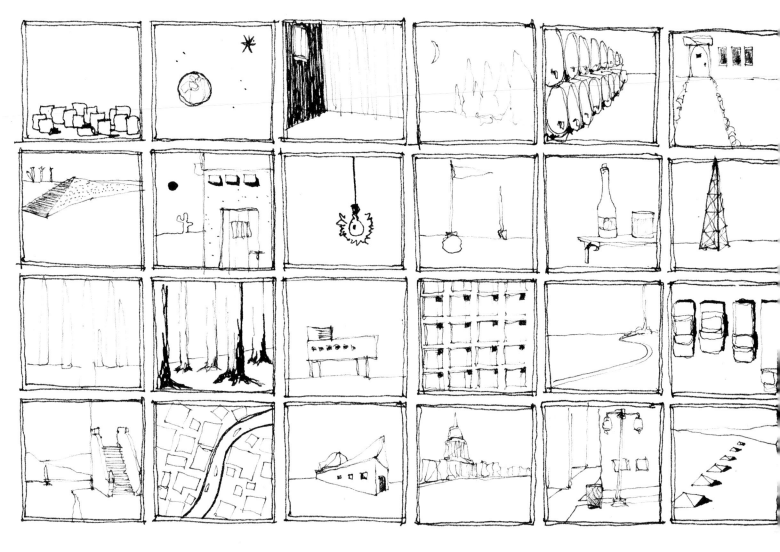

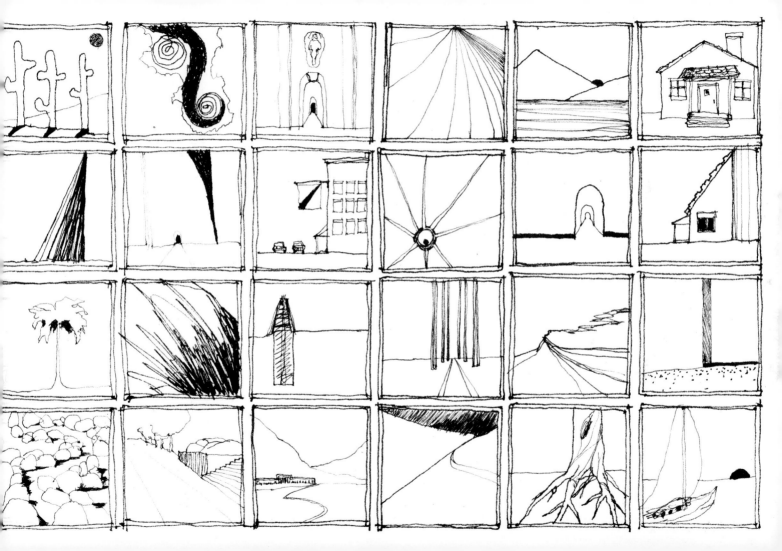

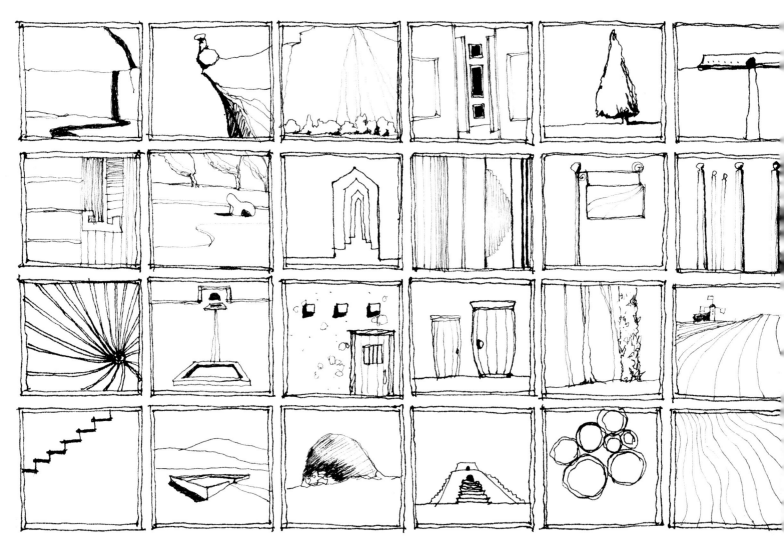

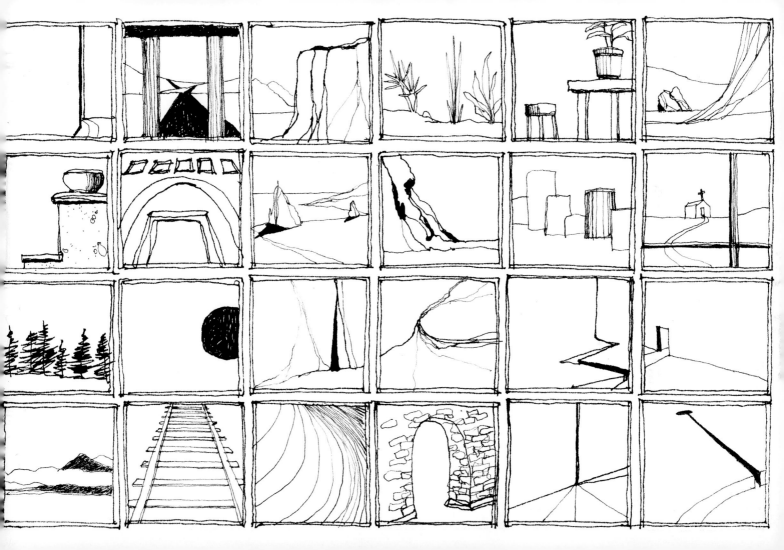

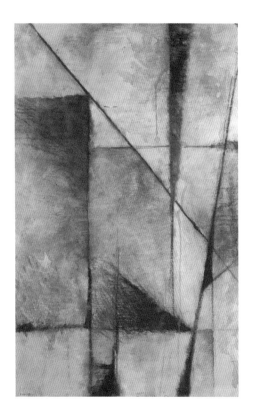

Abstract
Charcoal, pastel, watercolor, and gouache on plywood
13"x23"

Abstracts

Drawings can start with no preconceived image in mind or start with a preconceived image that never materializes on the canvas, but somehow, it works.

The abstract is the object and composition.

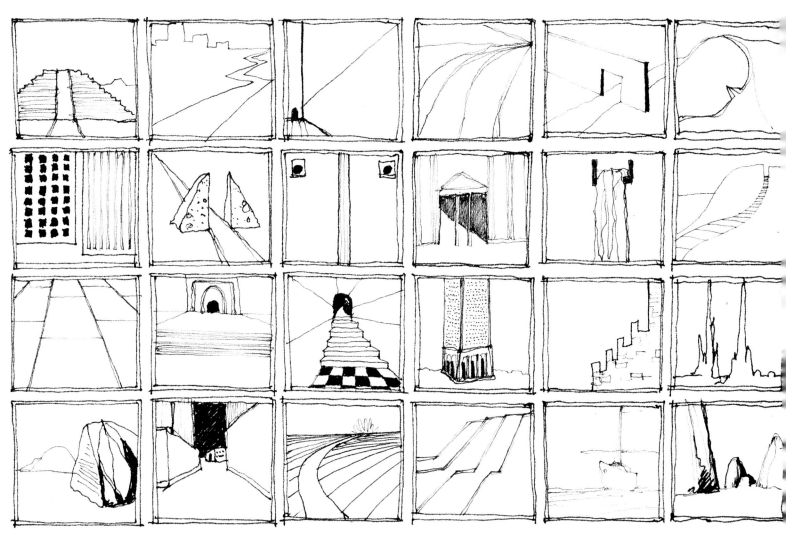

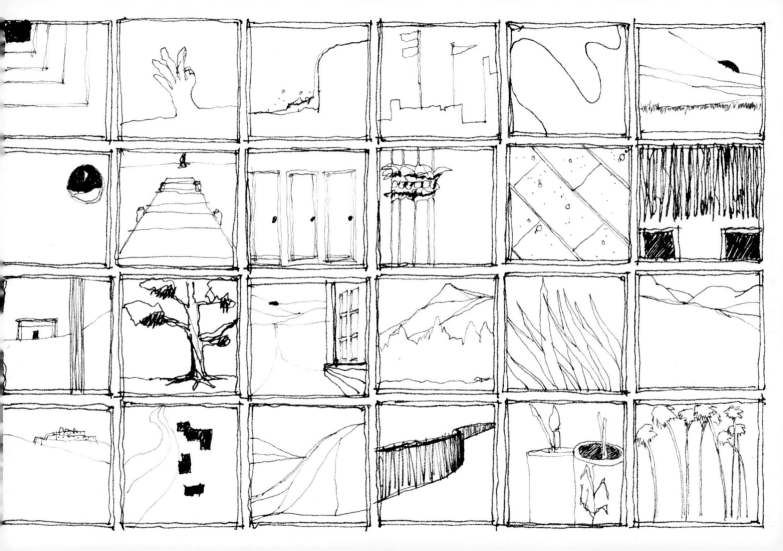

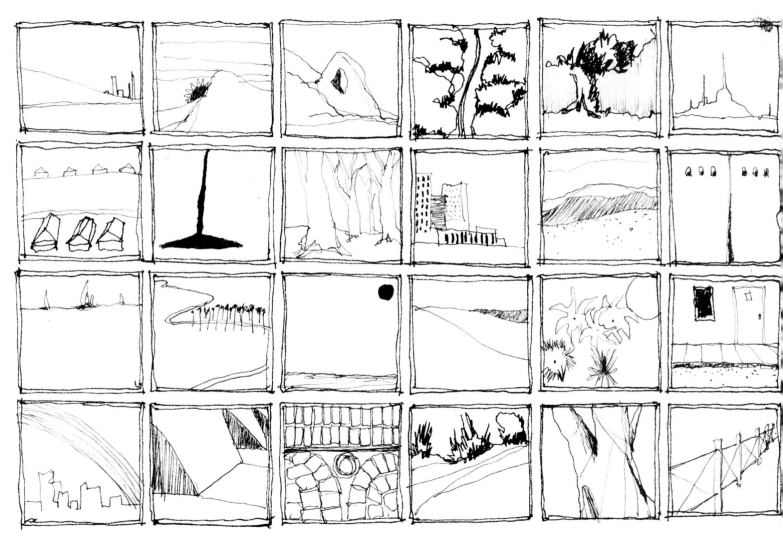

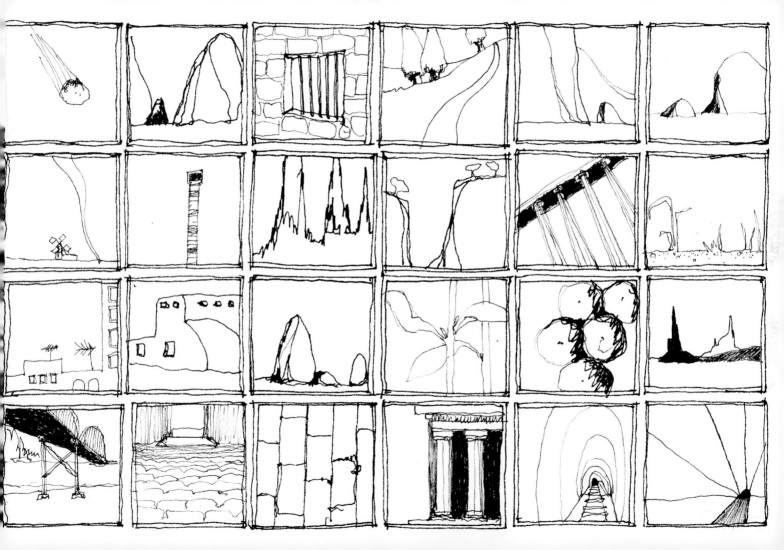

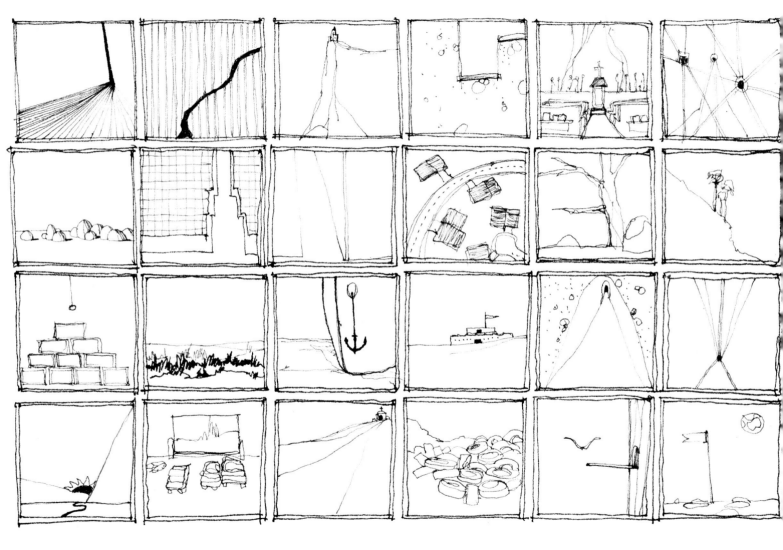

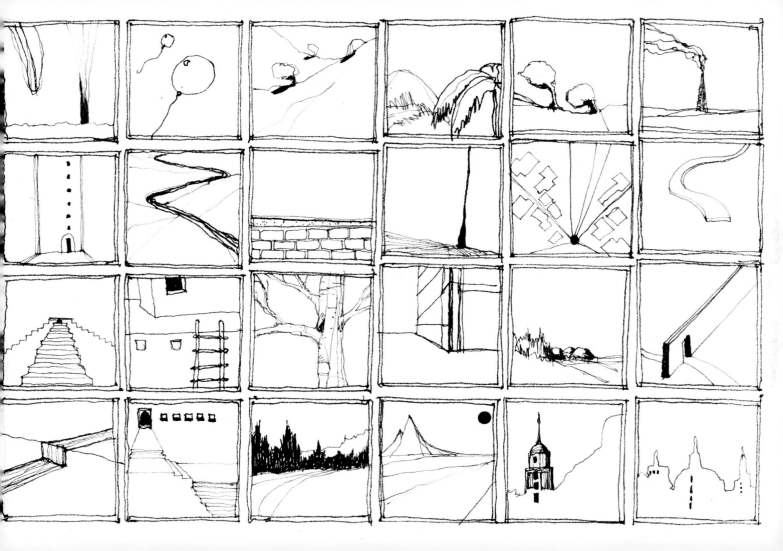

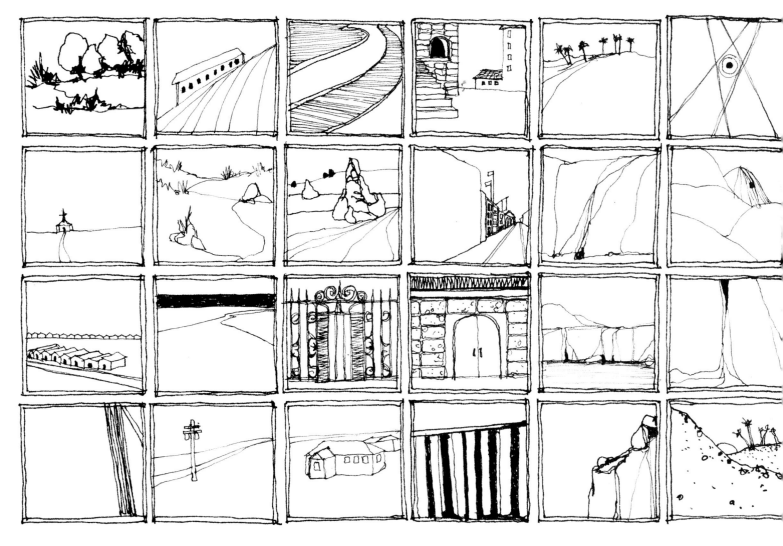

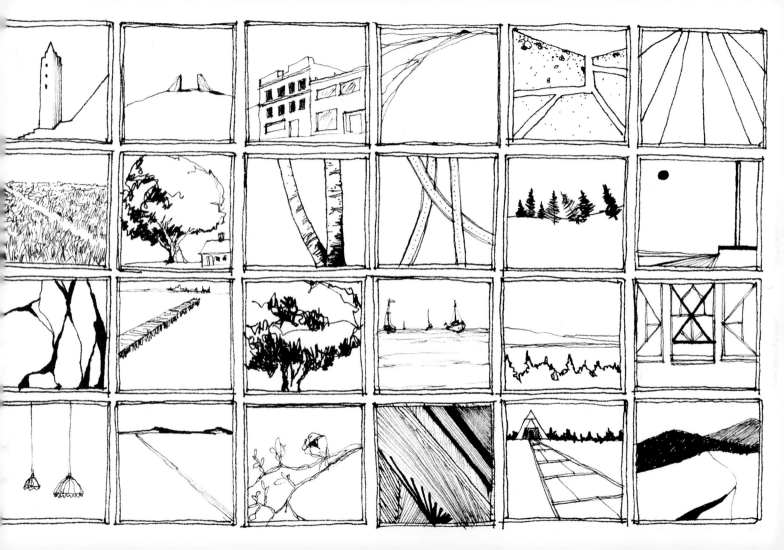

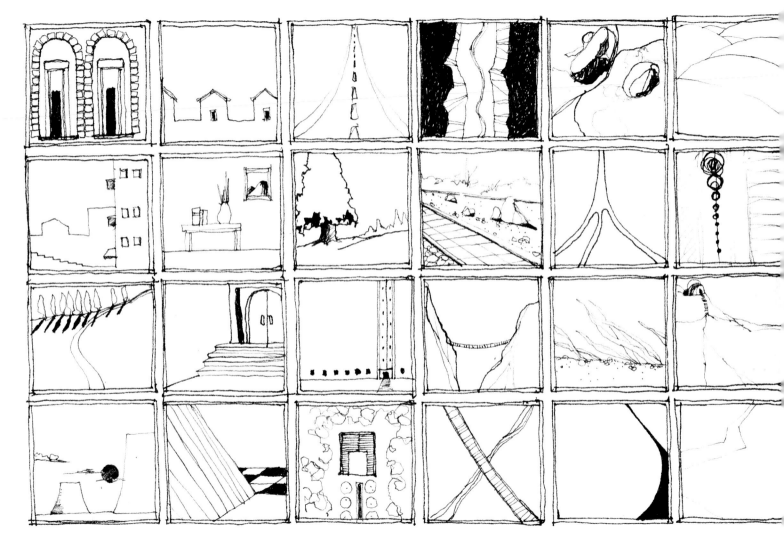

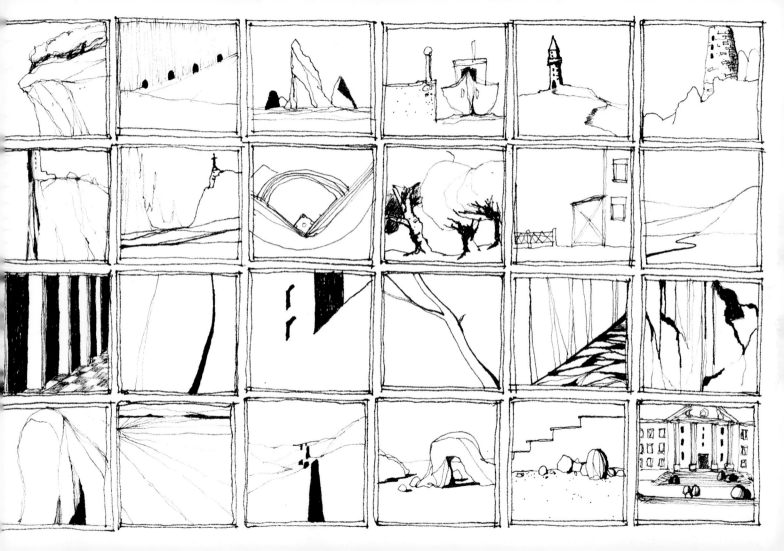

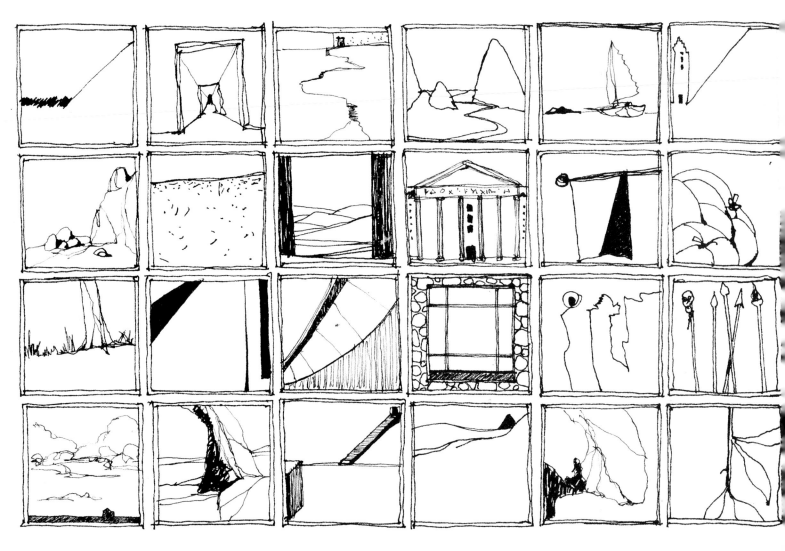

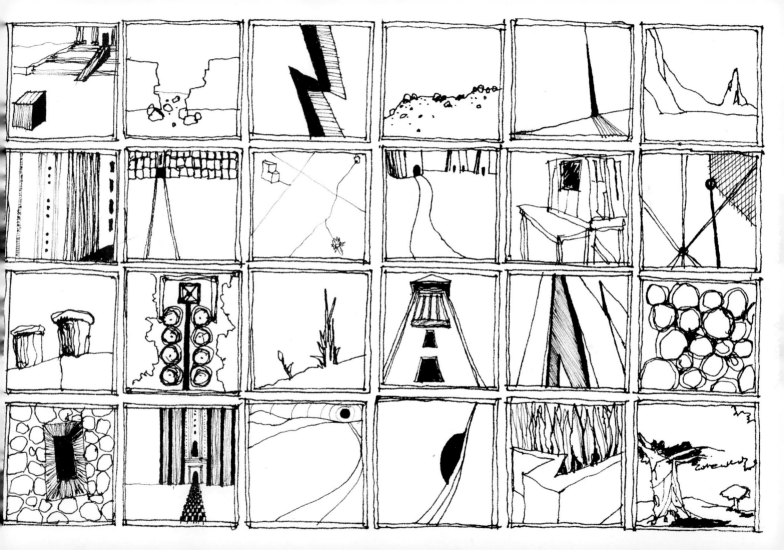

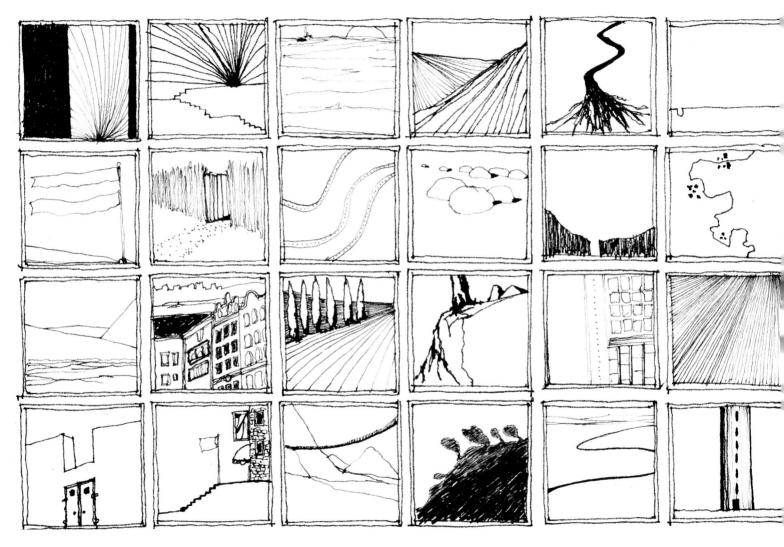

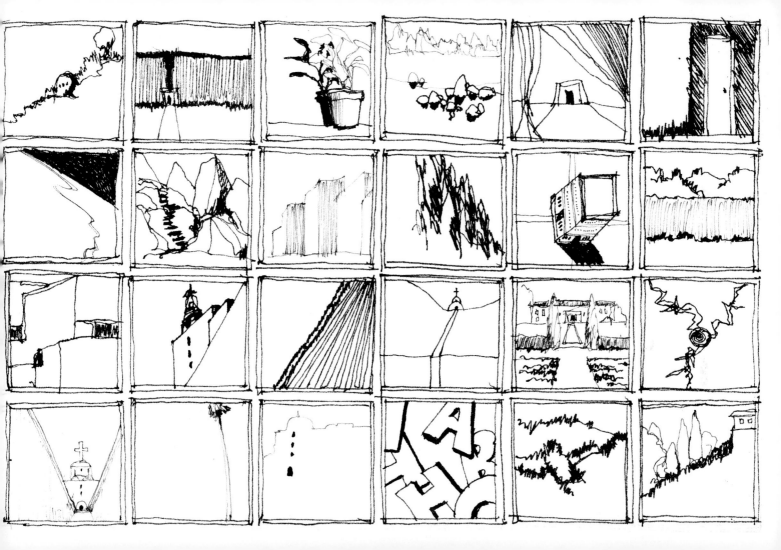

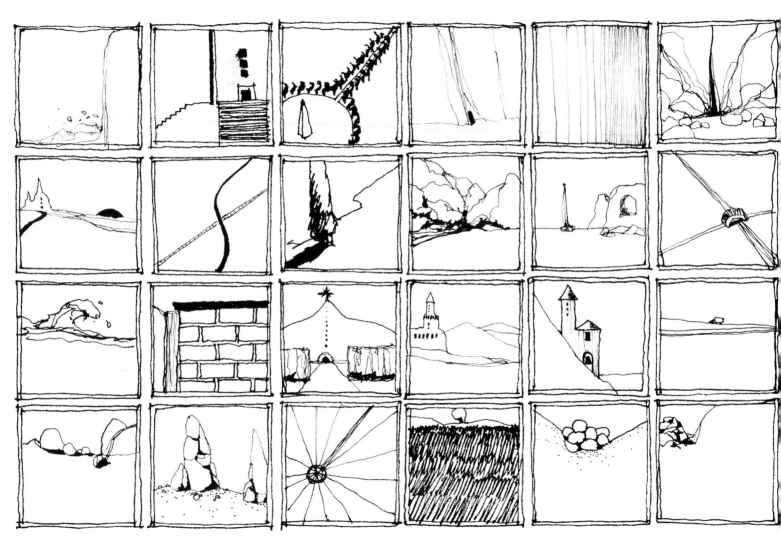

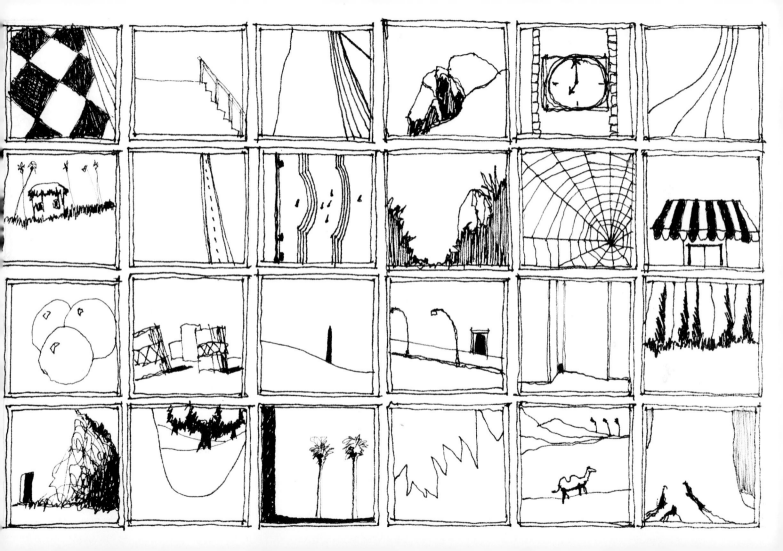

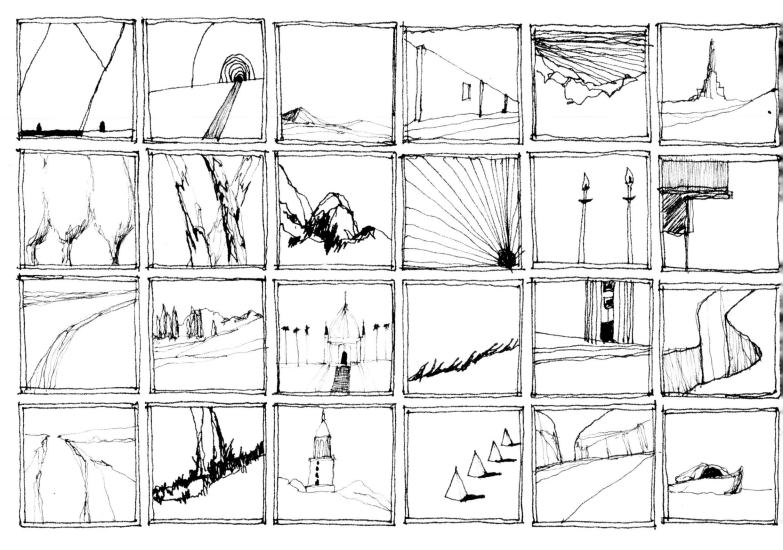

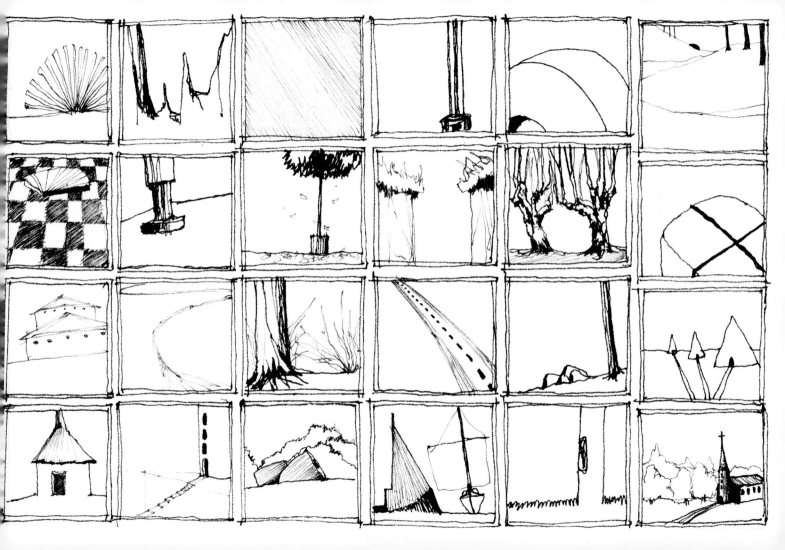

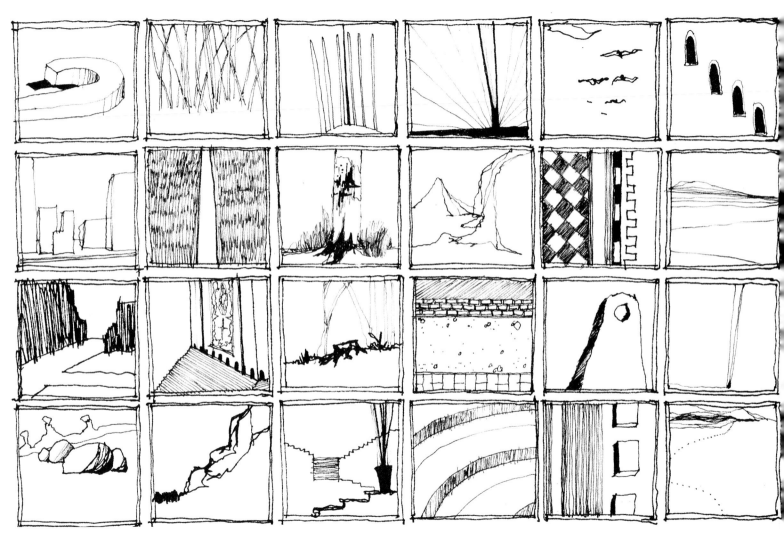

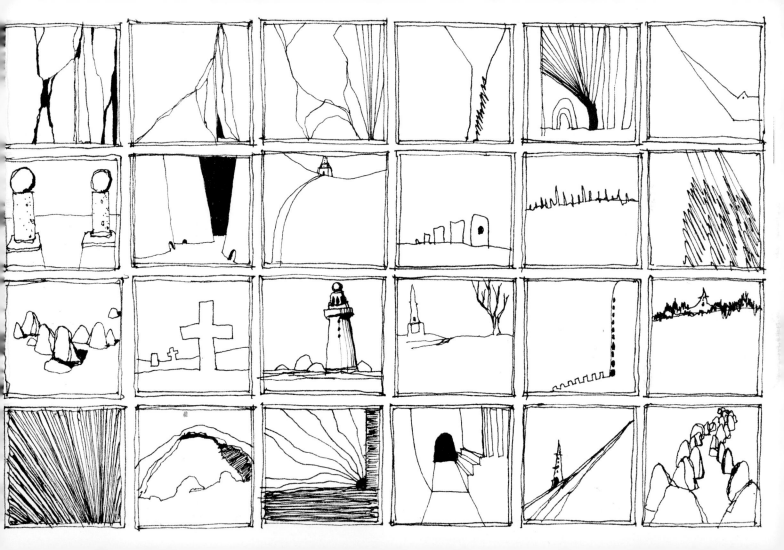

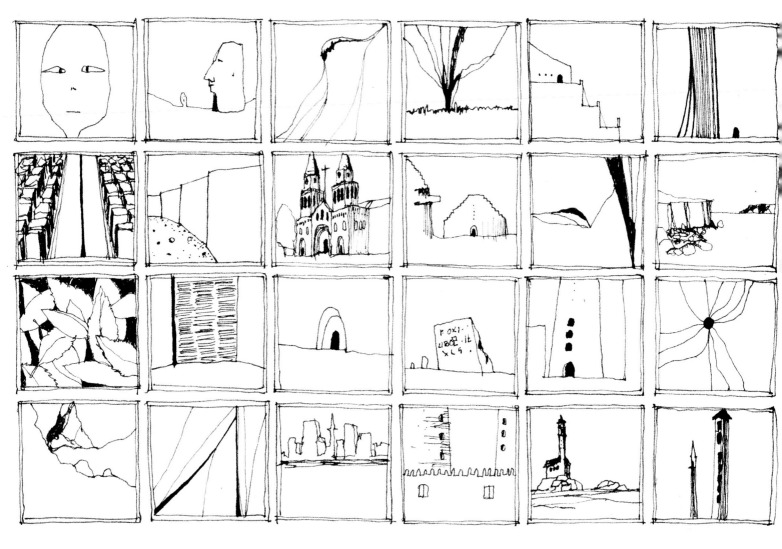

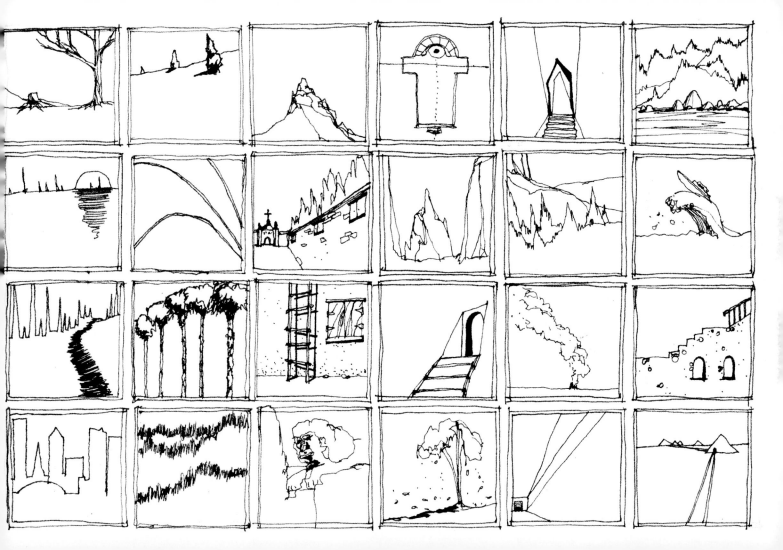

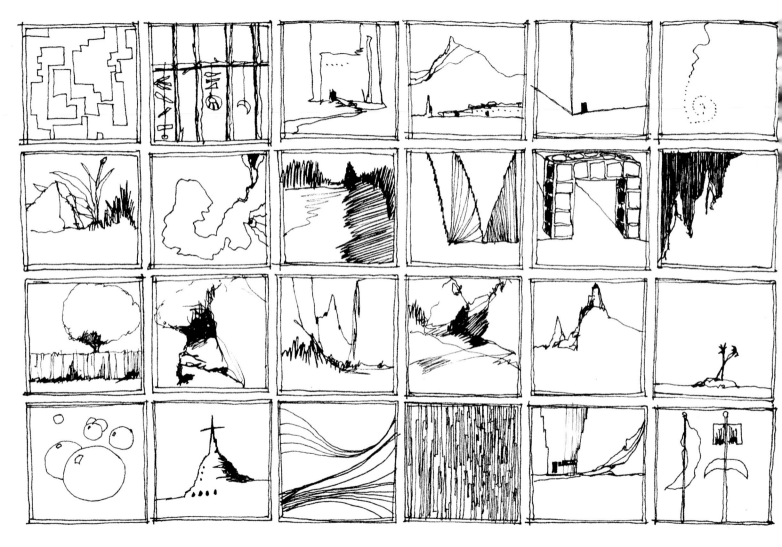

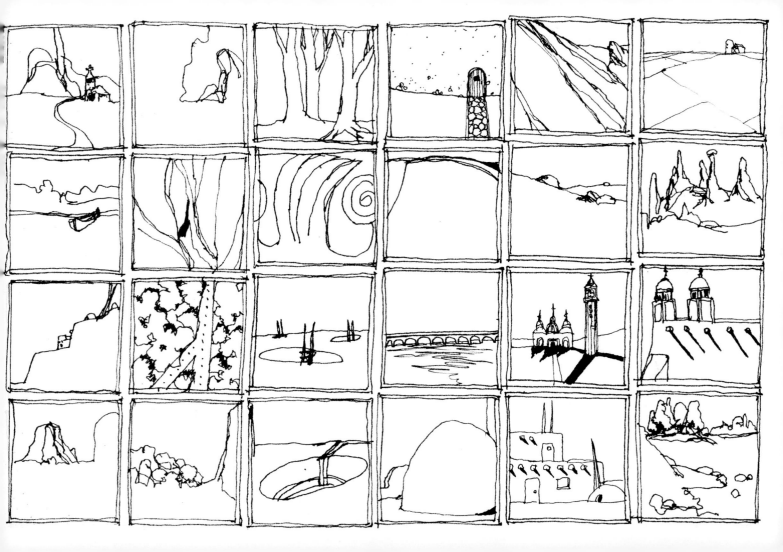

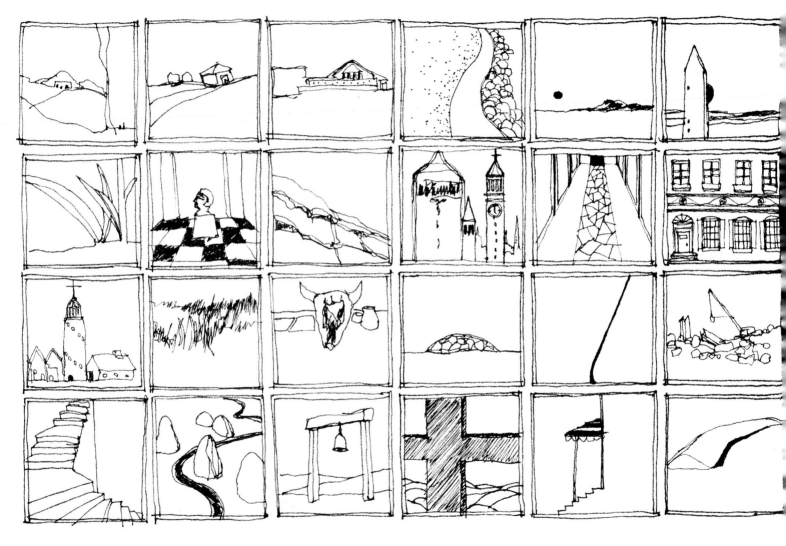

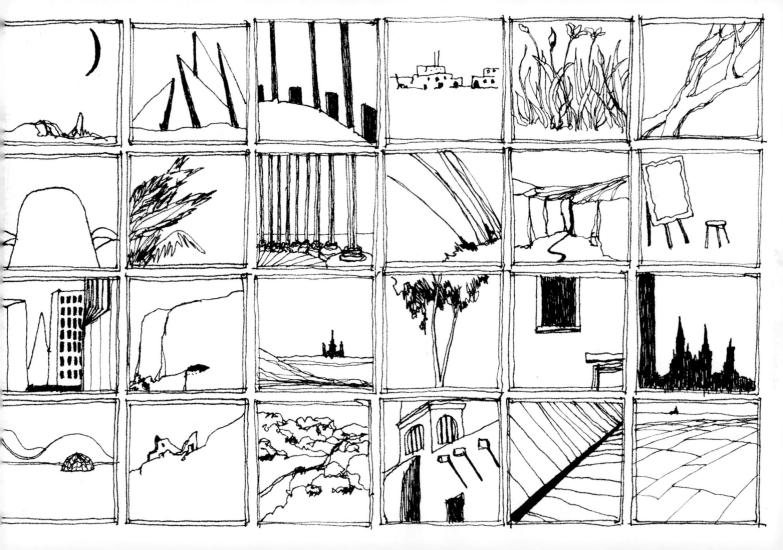

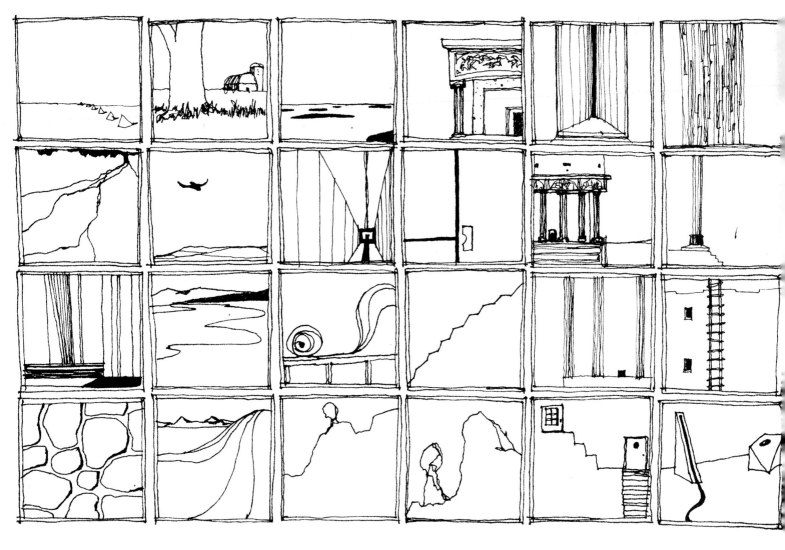

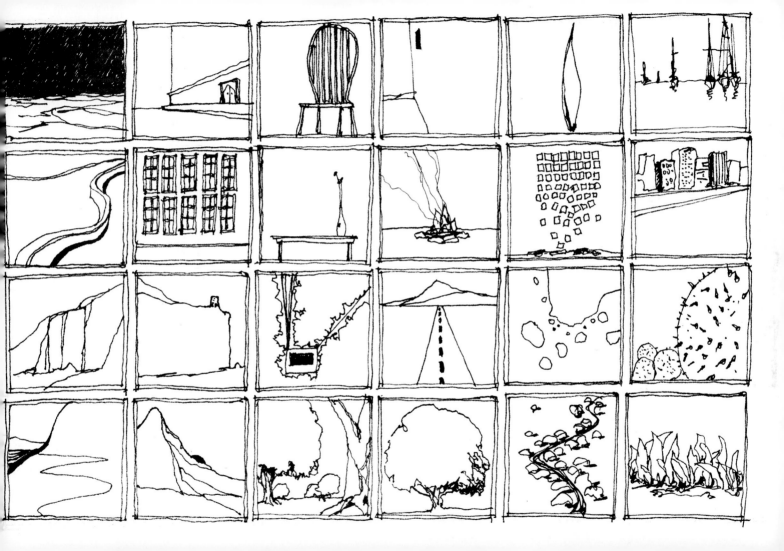

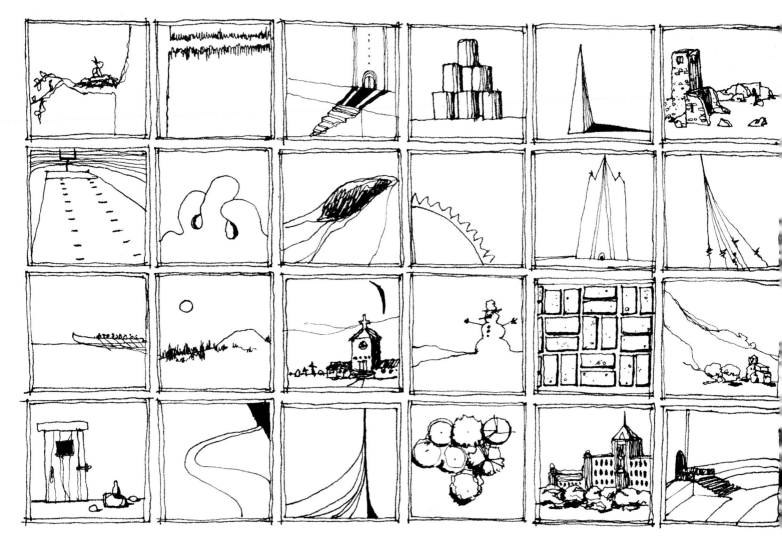

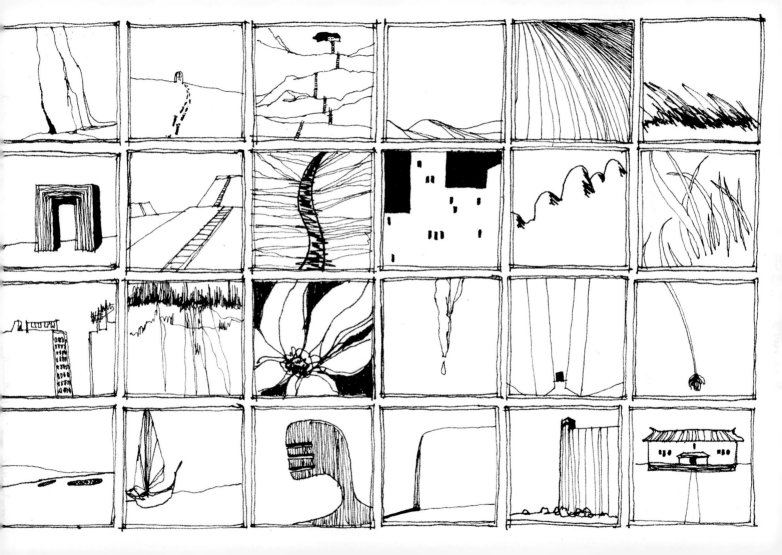

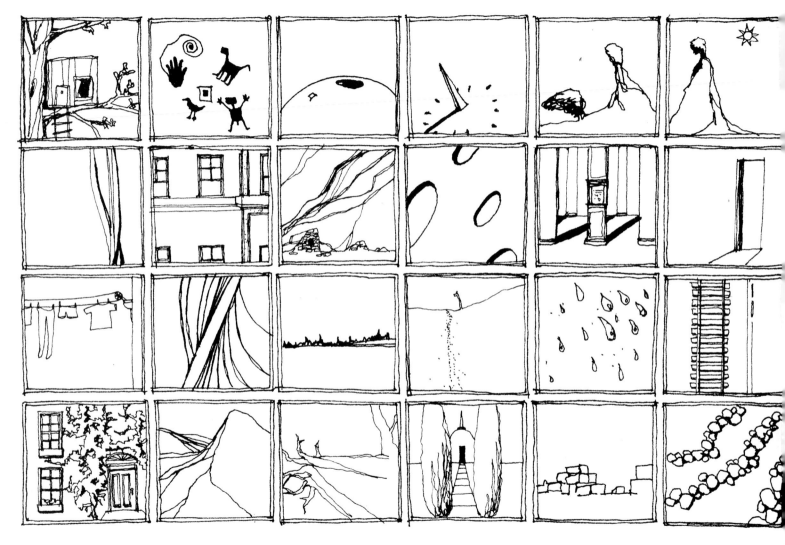

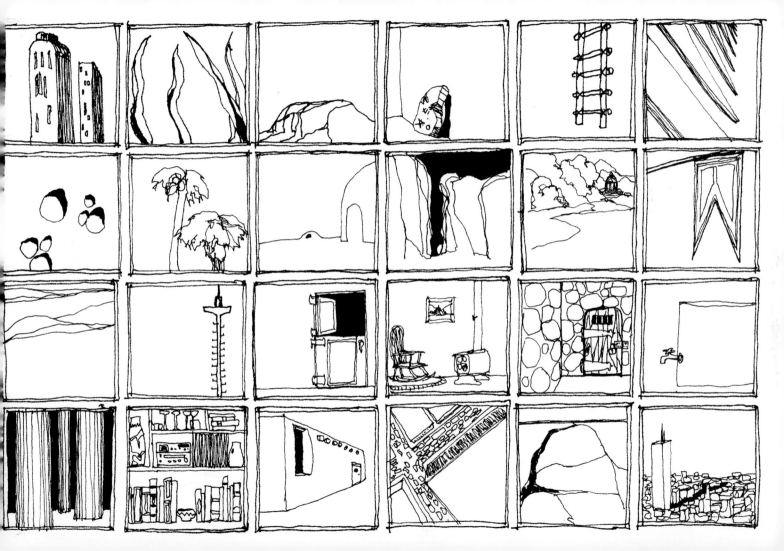

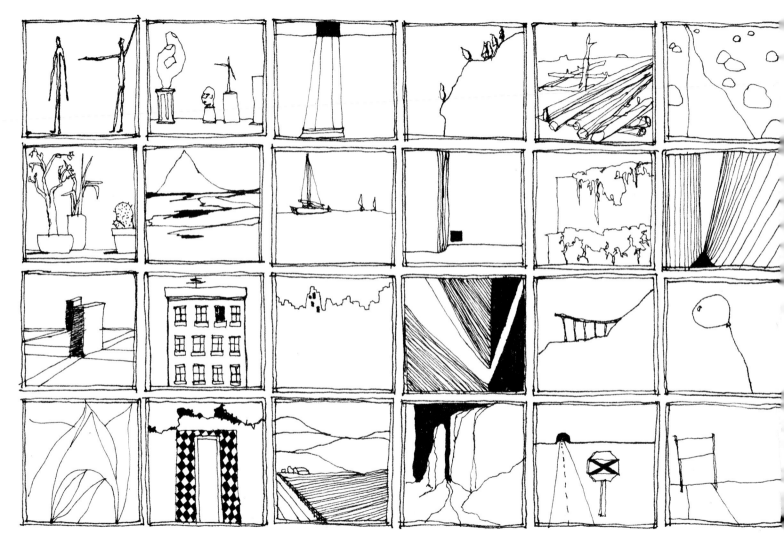

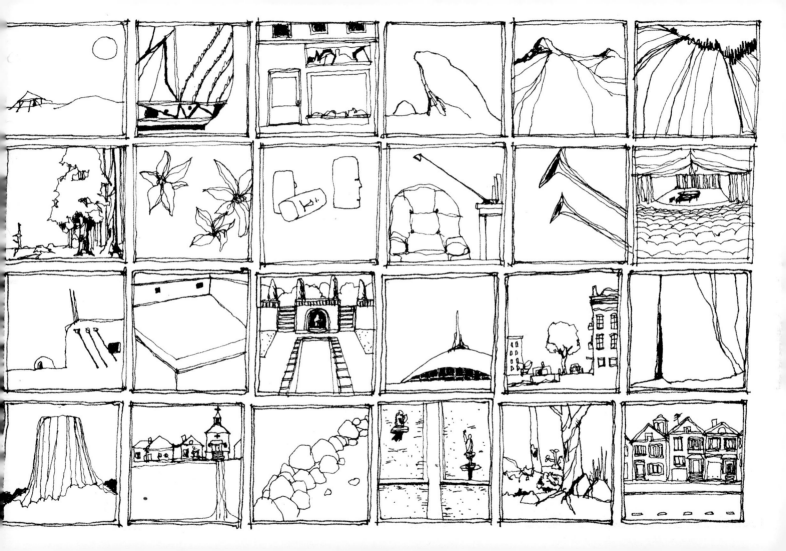

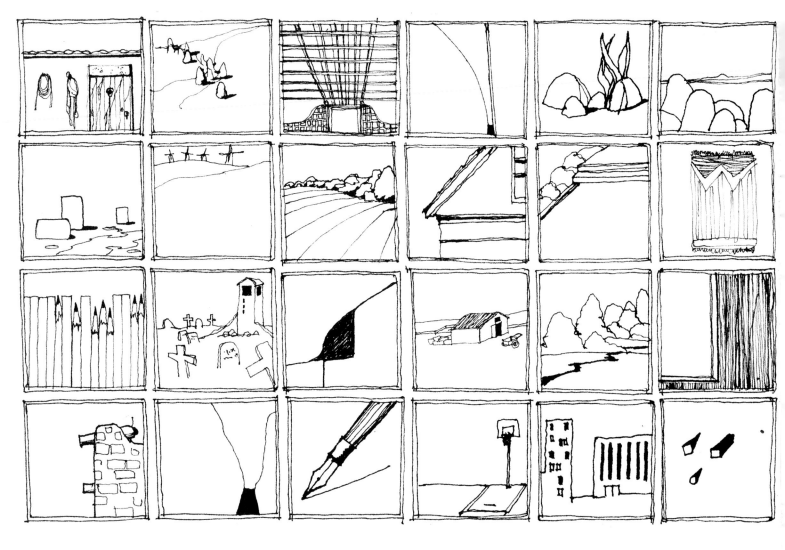

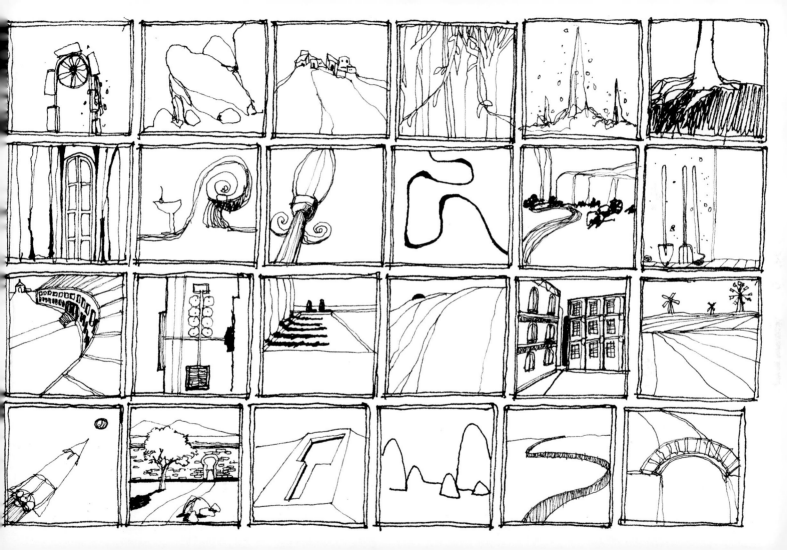

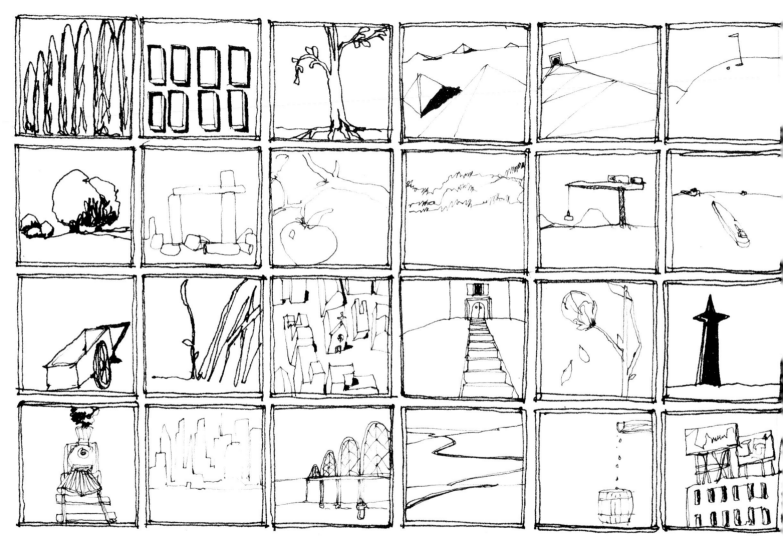

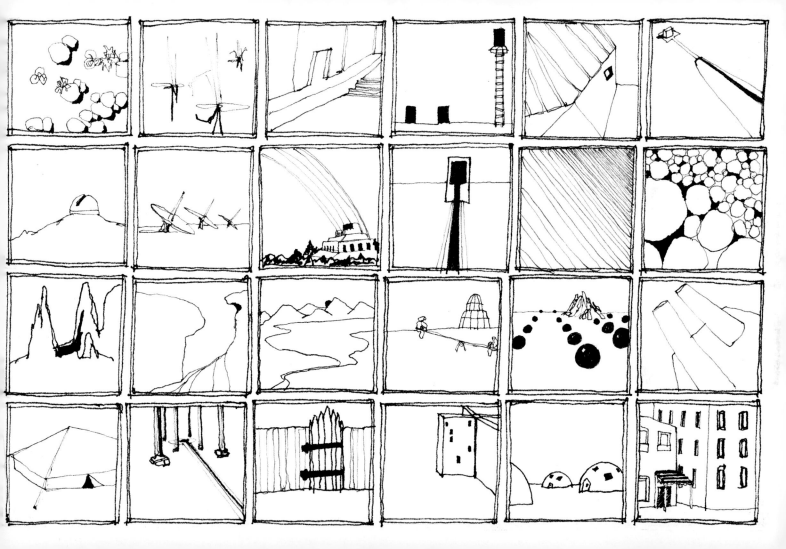

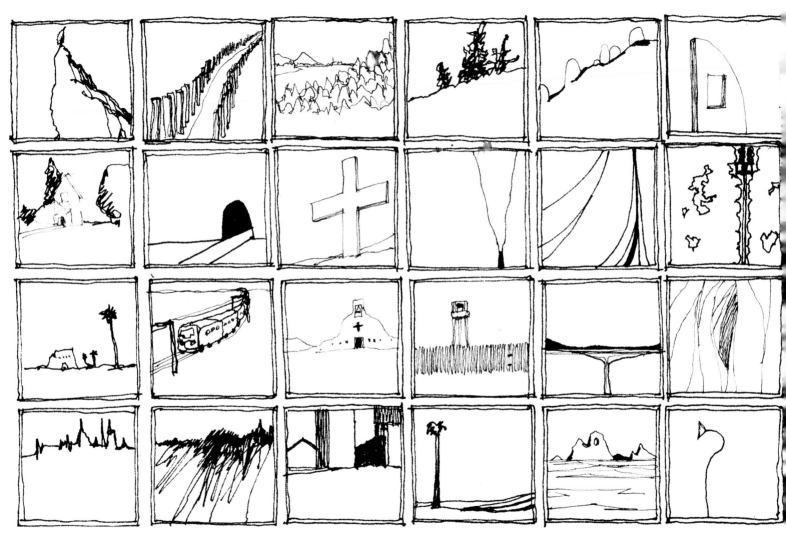

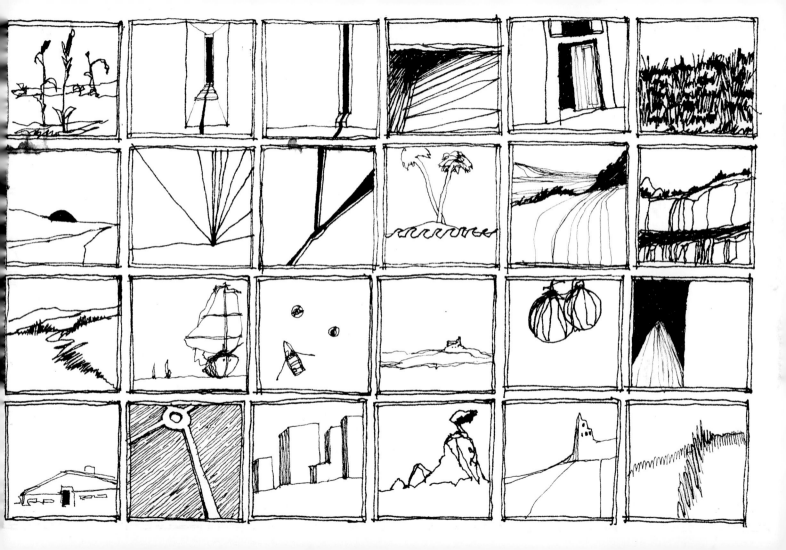

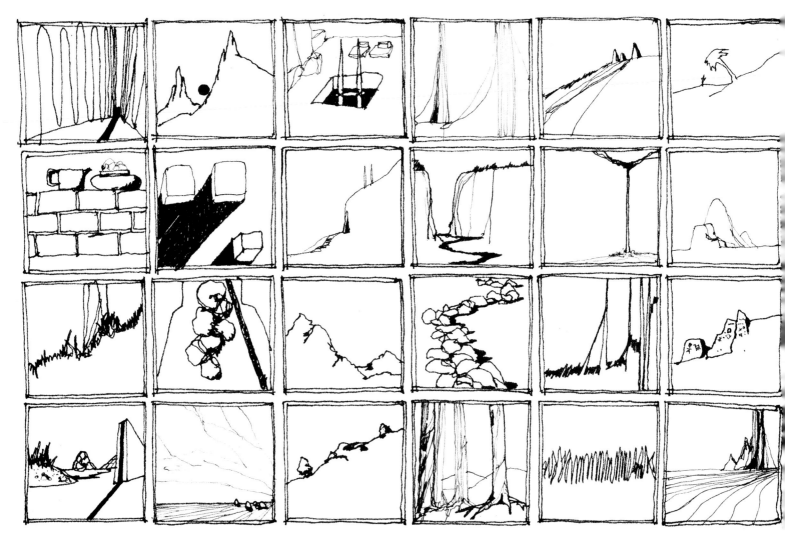

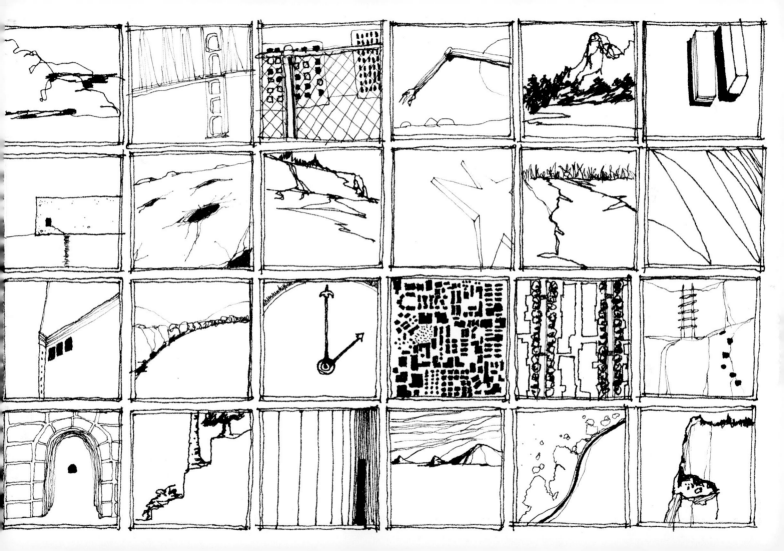

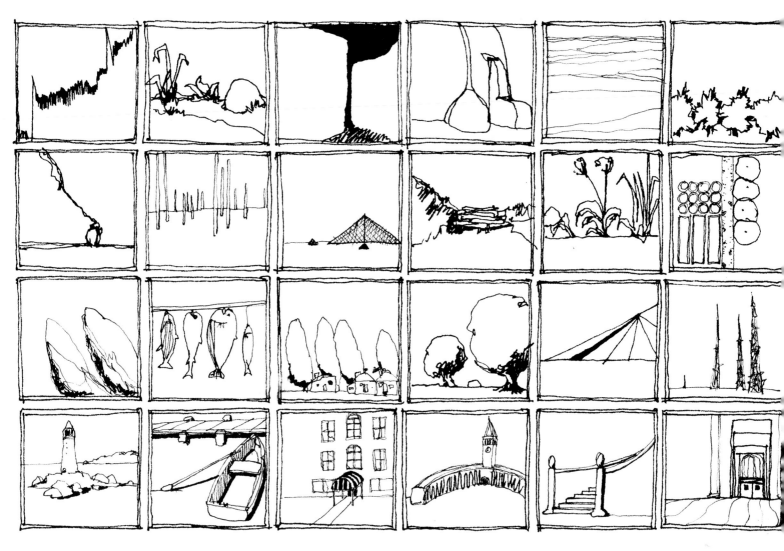

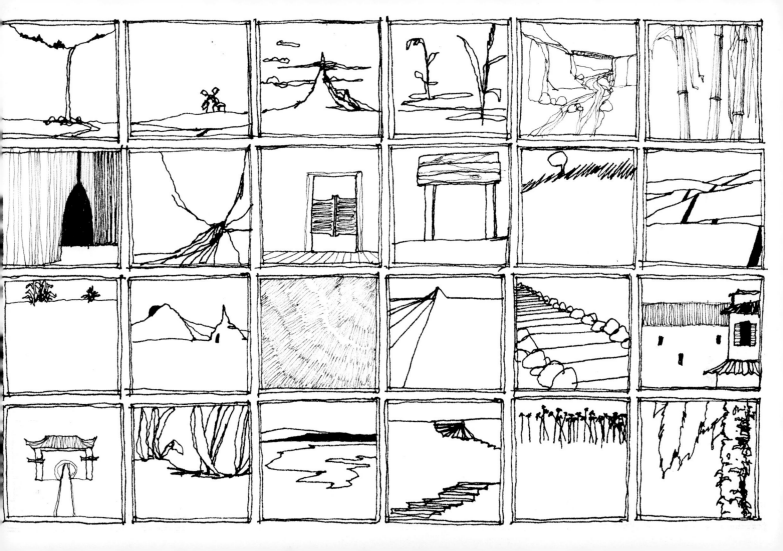

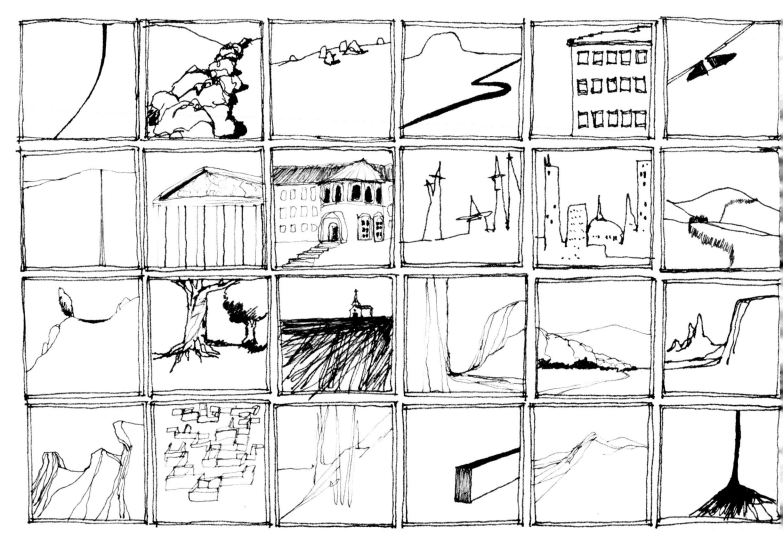

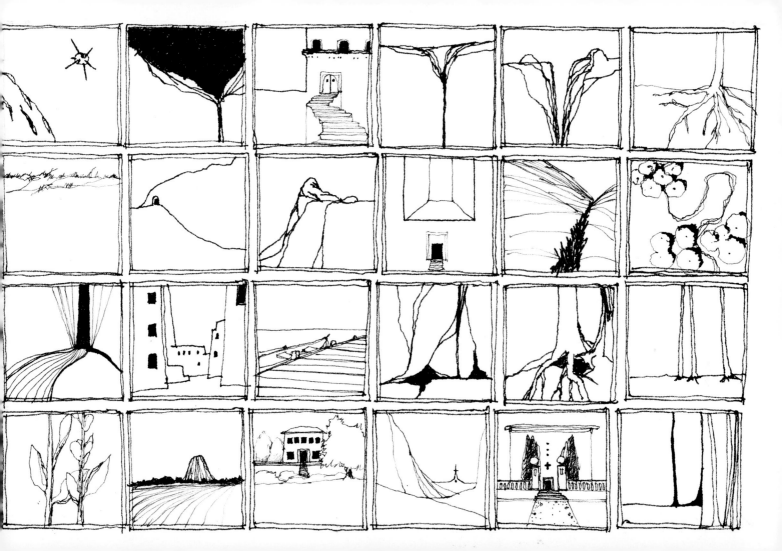

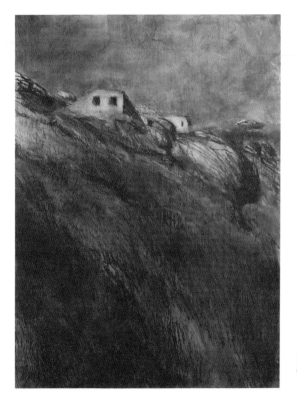

Headlands
Charcoal, pastel, watercolor, and gouache on plywood
18"x24"

Objects and Artifacts

I love ordinary, common objects. They are often overlooked. The way they are composed with one another in our everyday lives, tells a story.

I'm drawn to isolated geometric shapes in a natural landscape, as their forms strengthen one another.

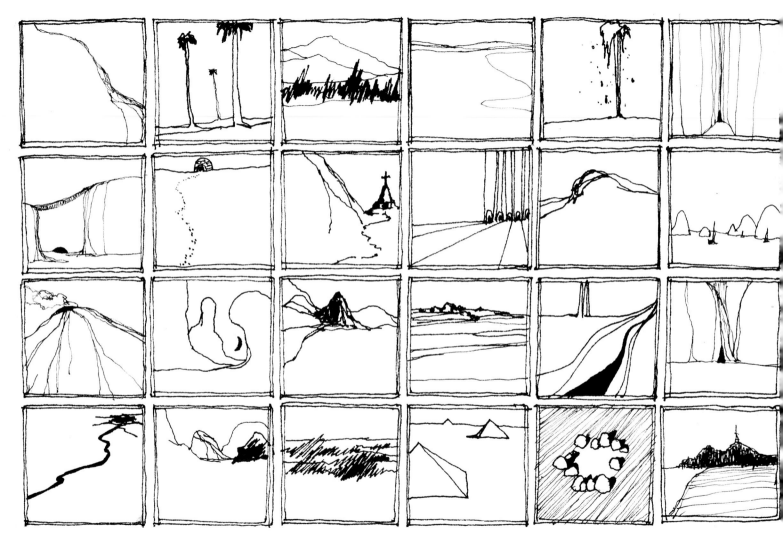

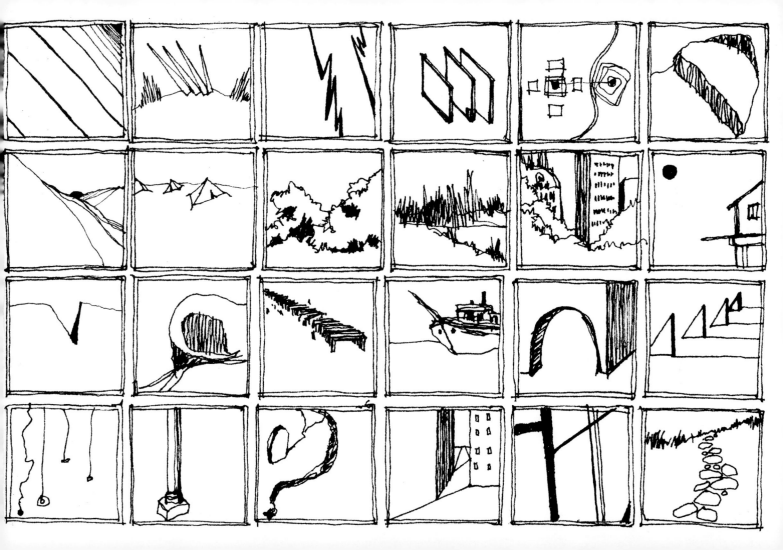

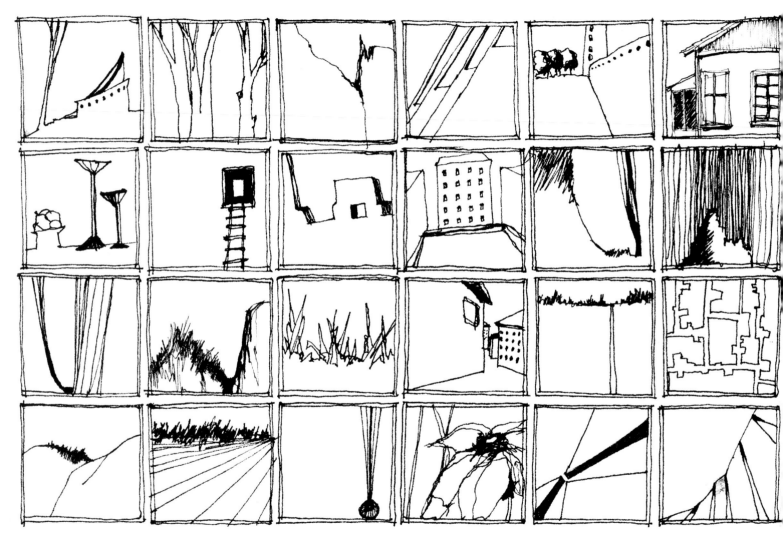

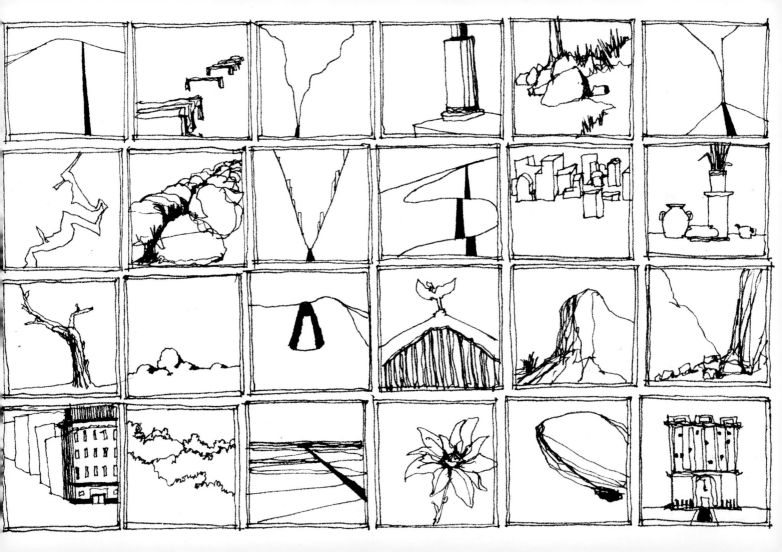

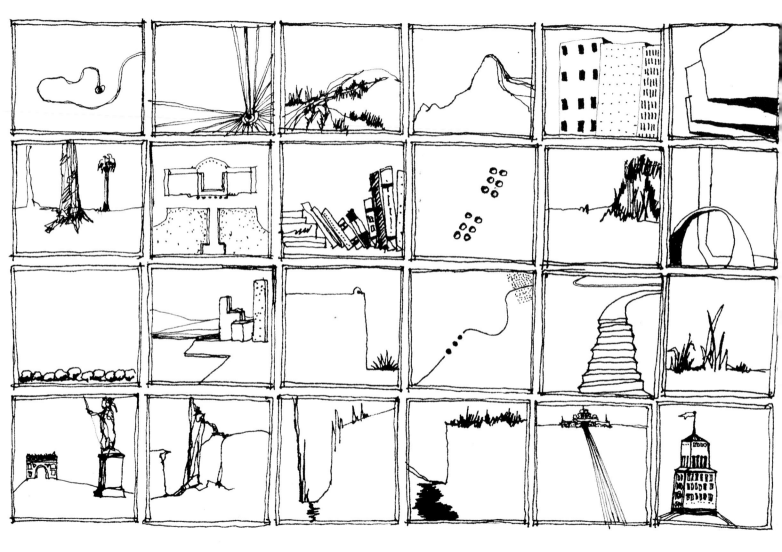

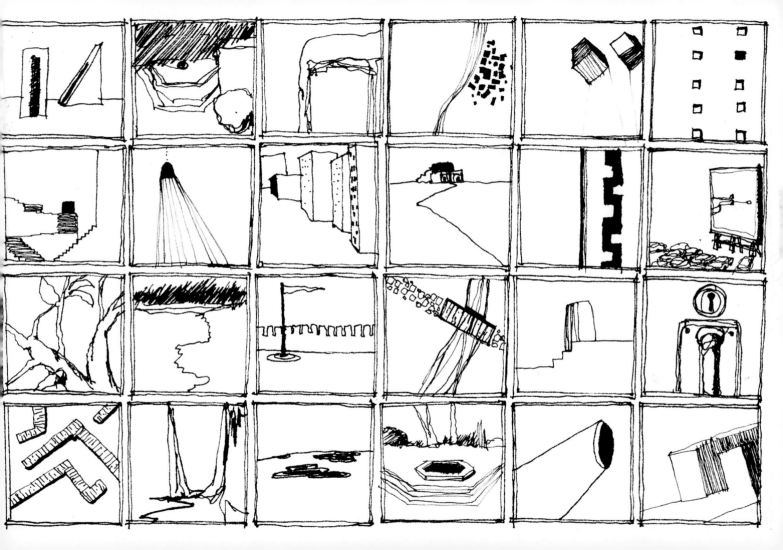

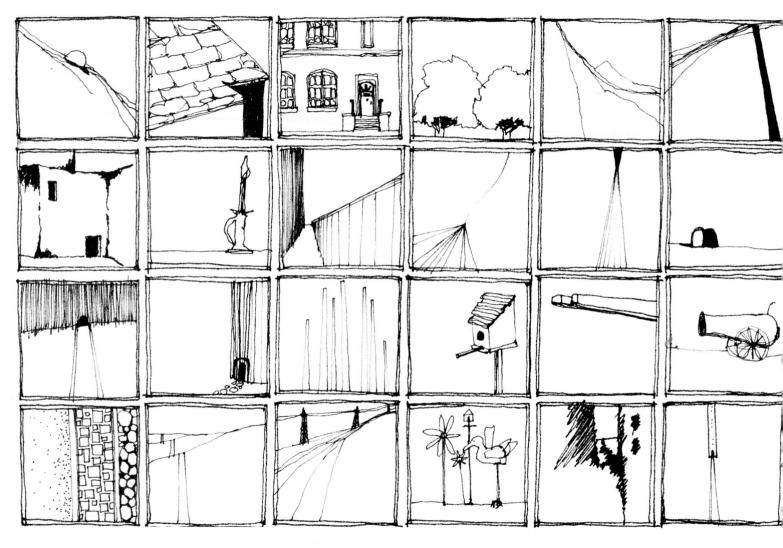

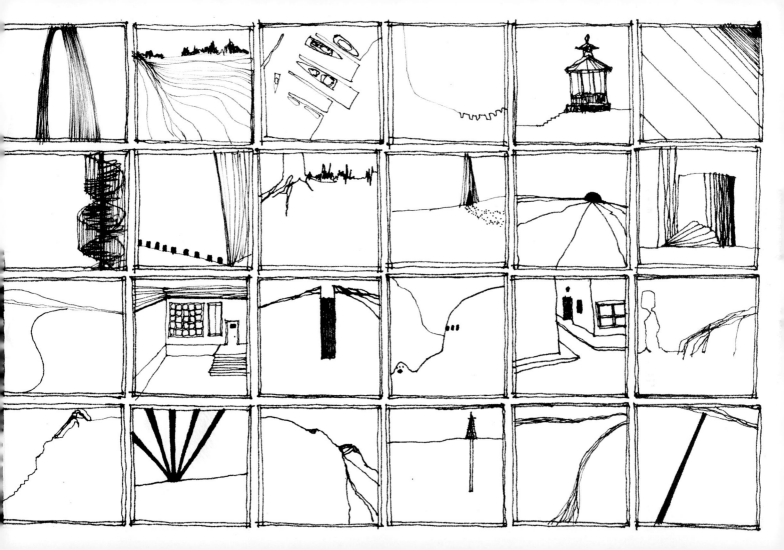

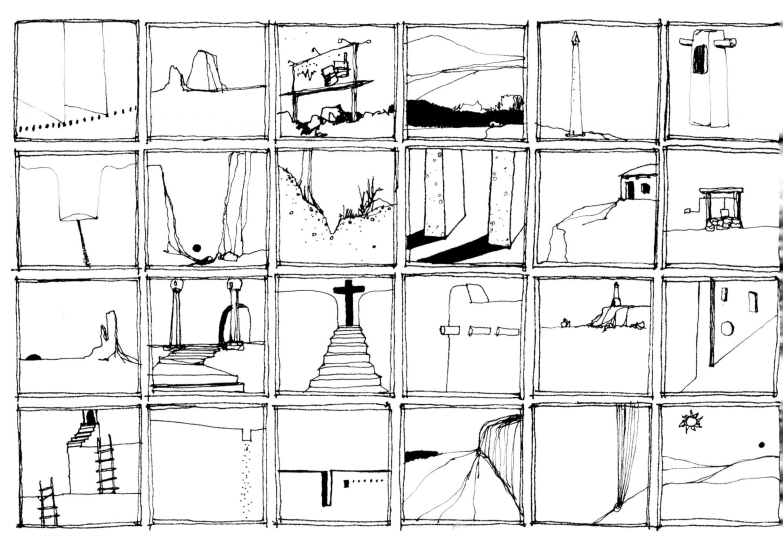

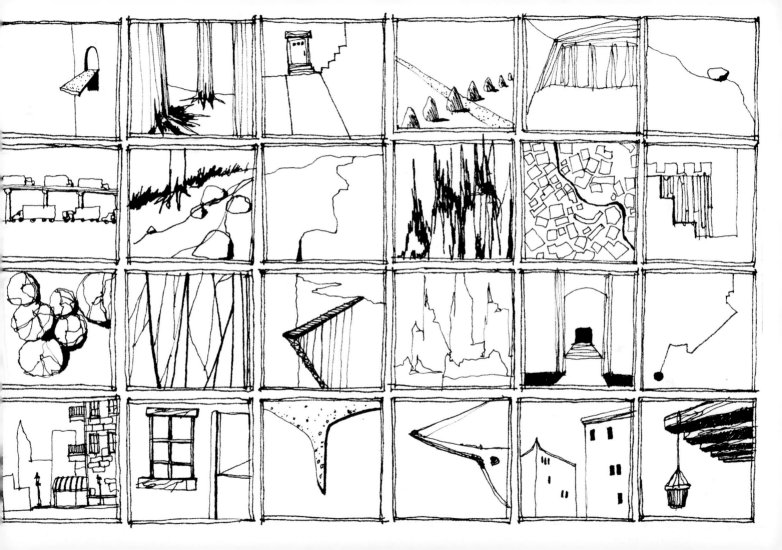

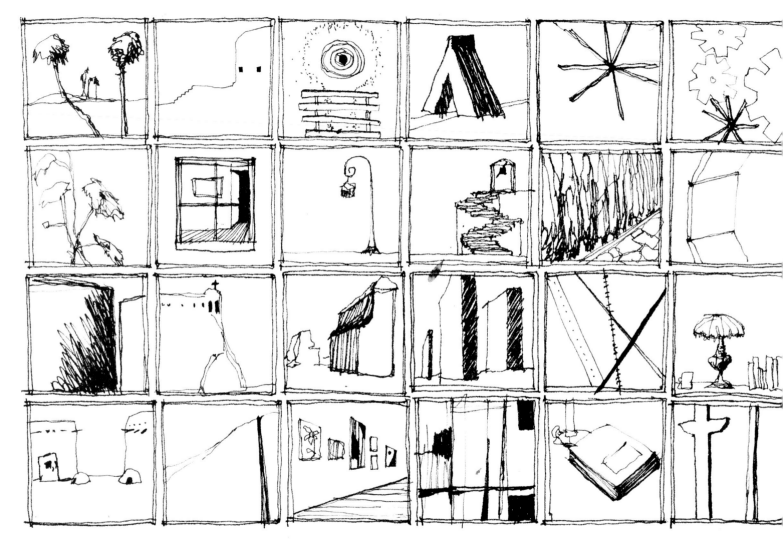

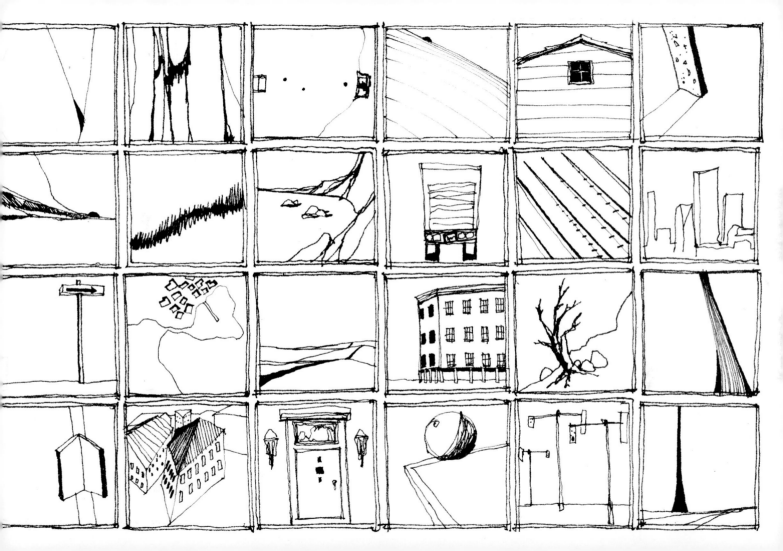

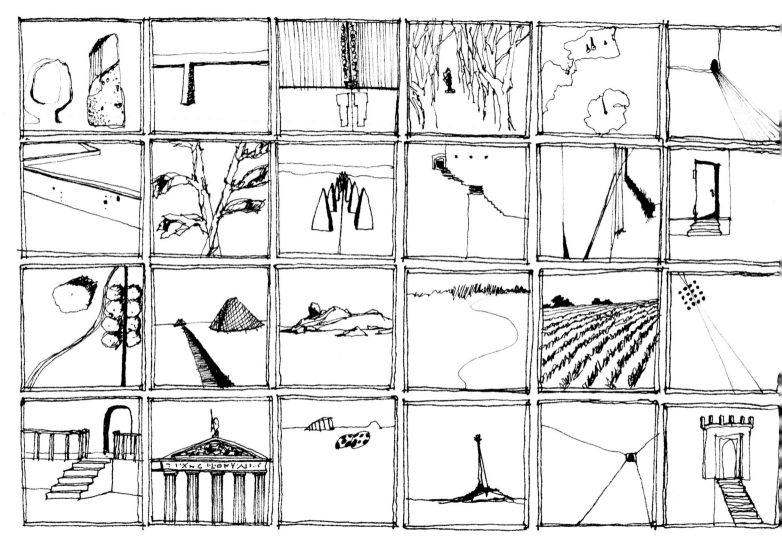

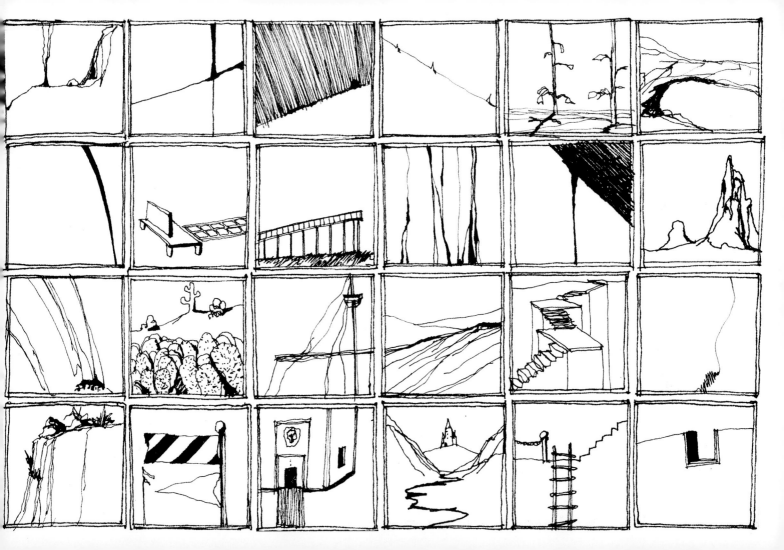

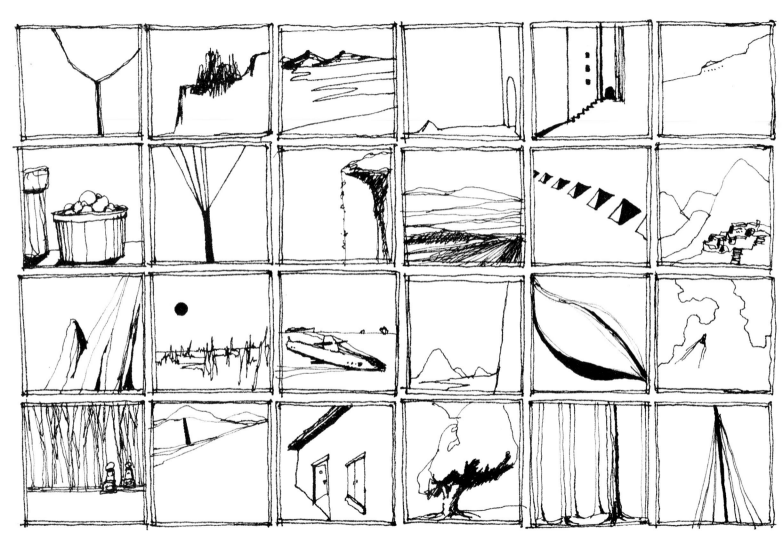

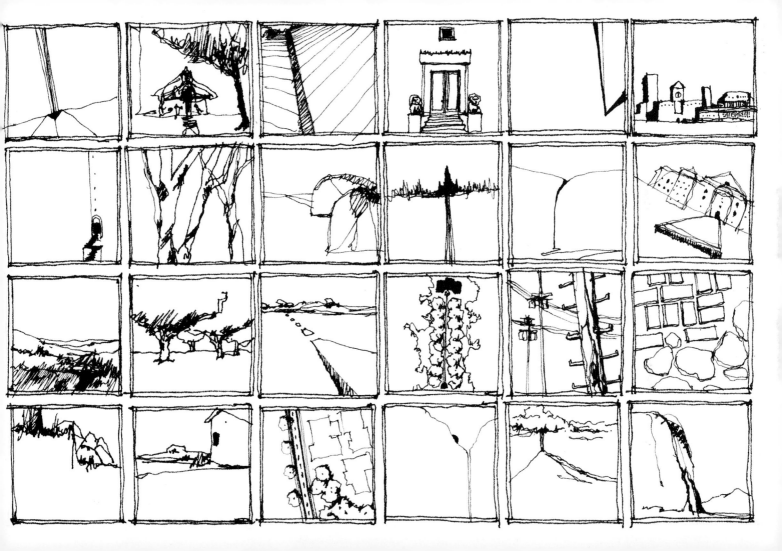

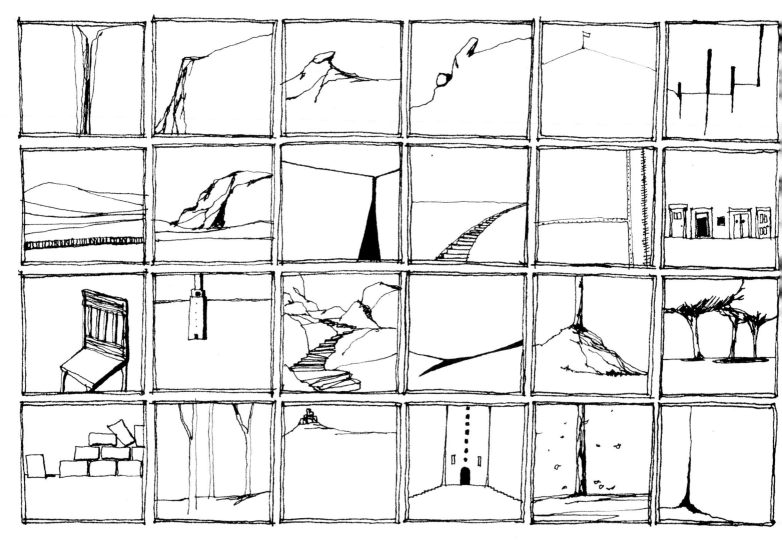

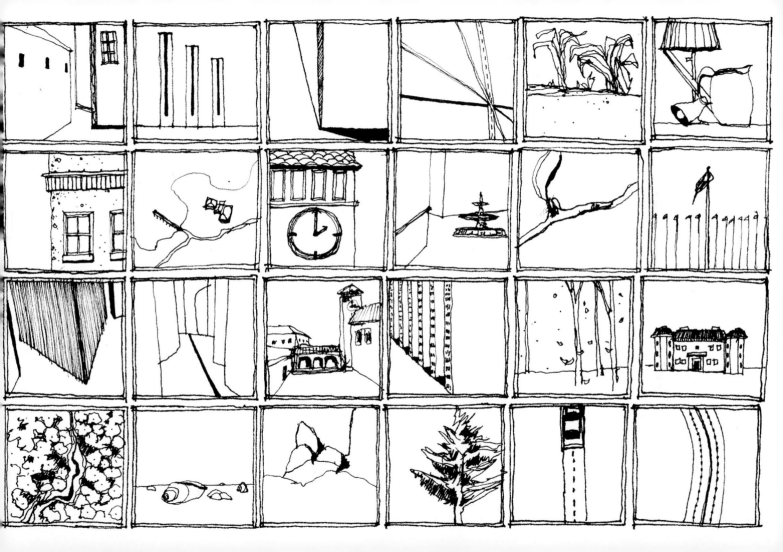

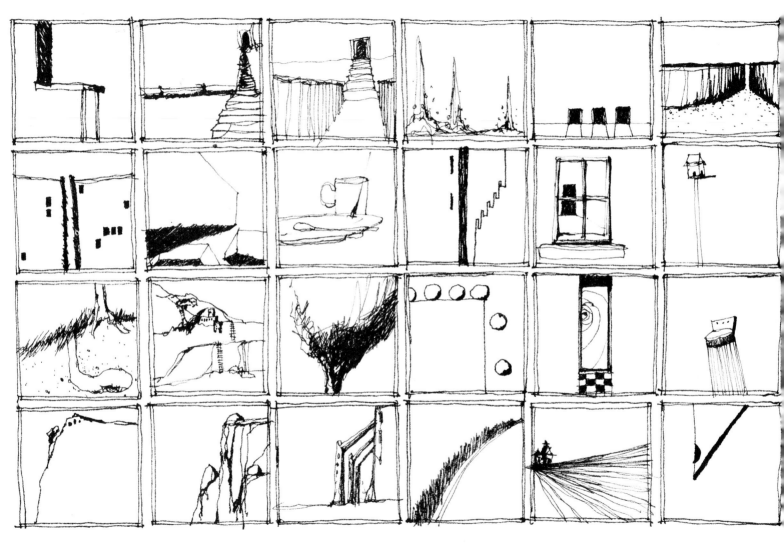

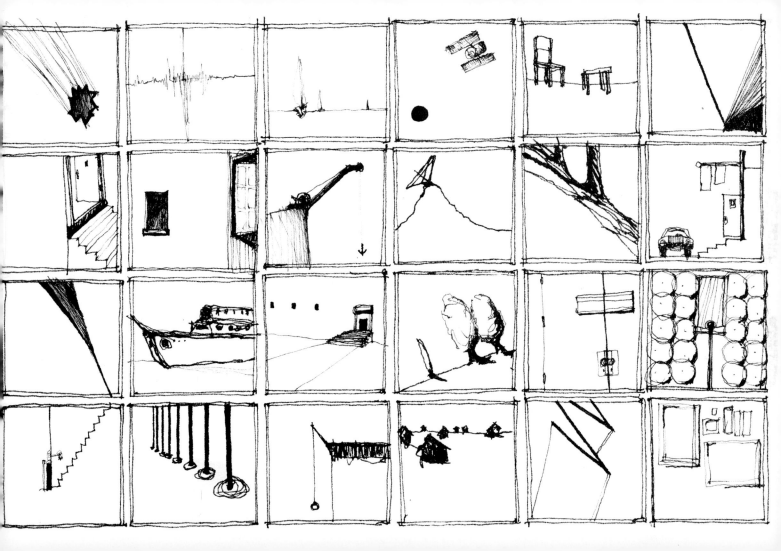

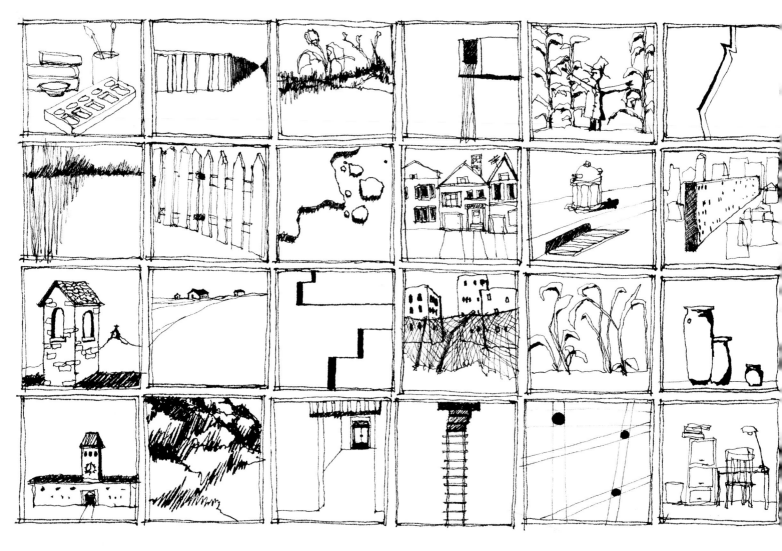

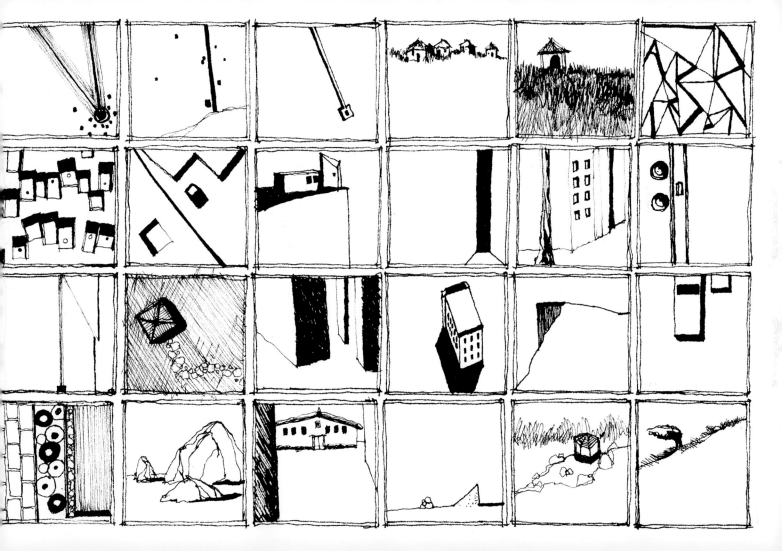

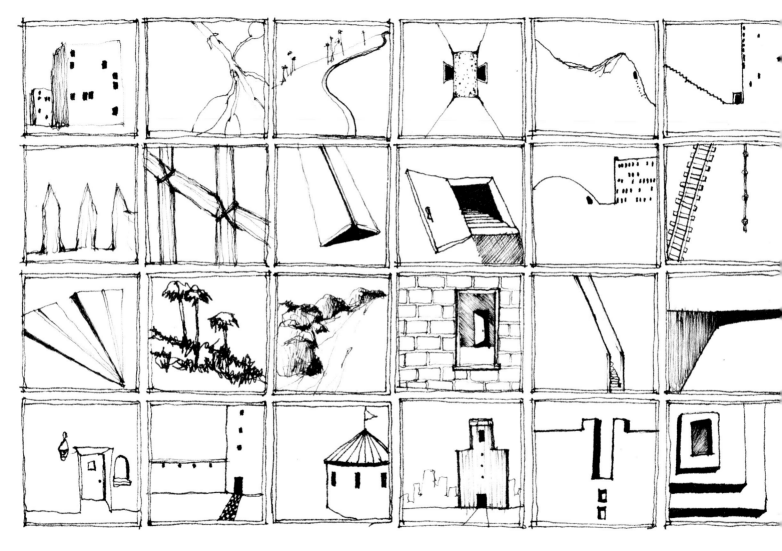

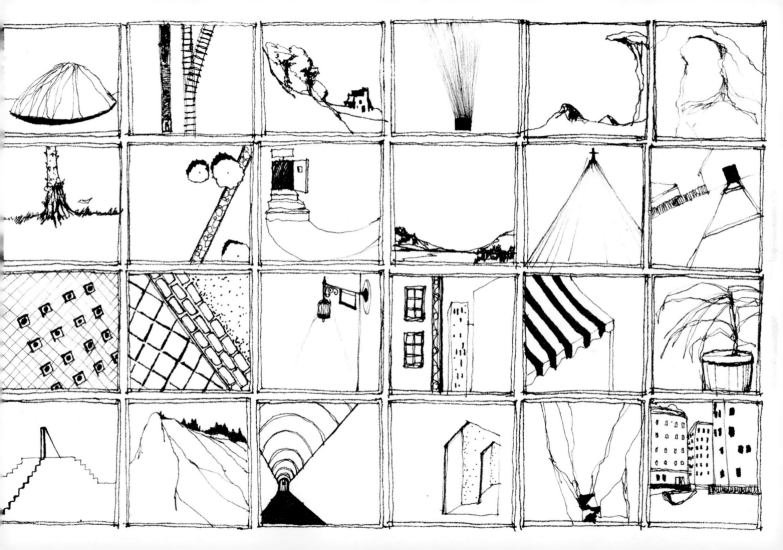

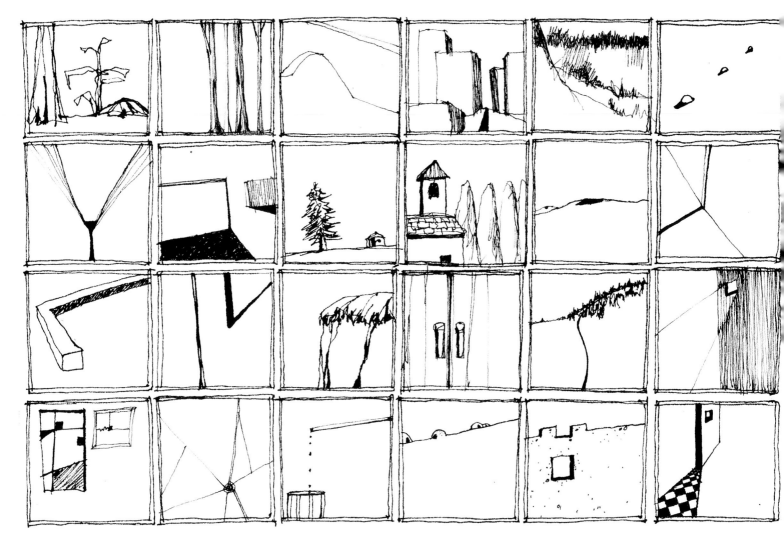

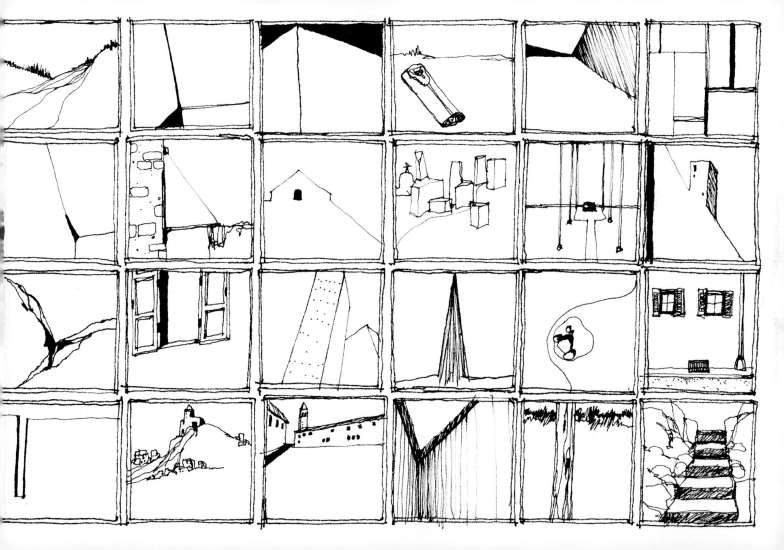

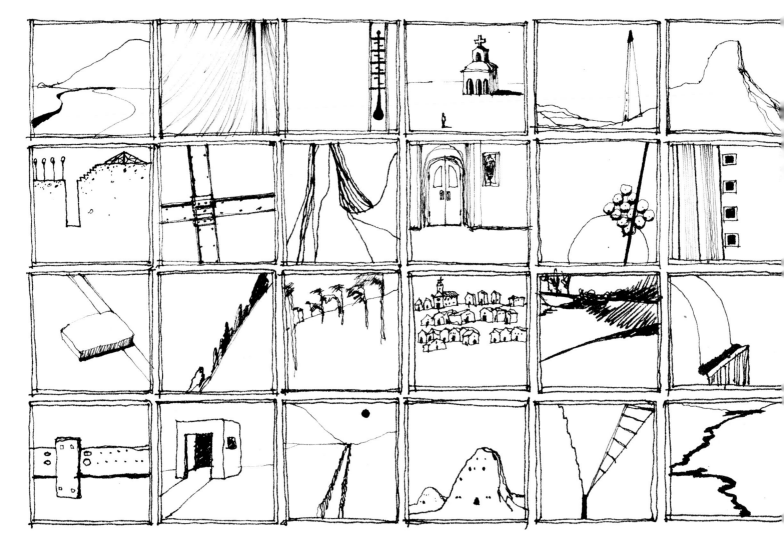

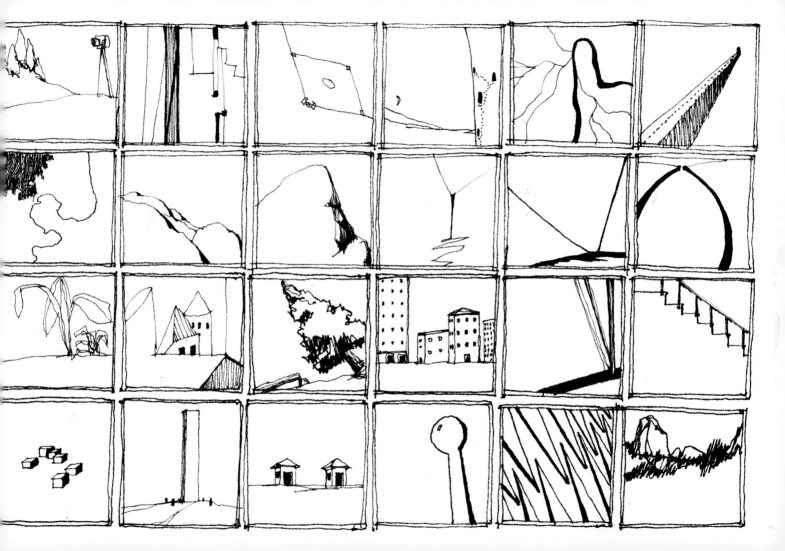

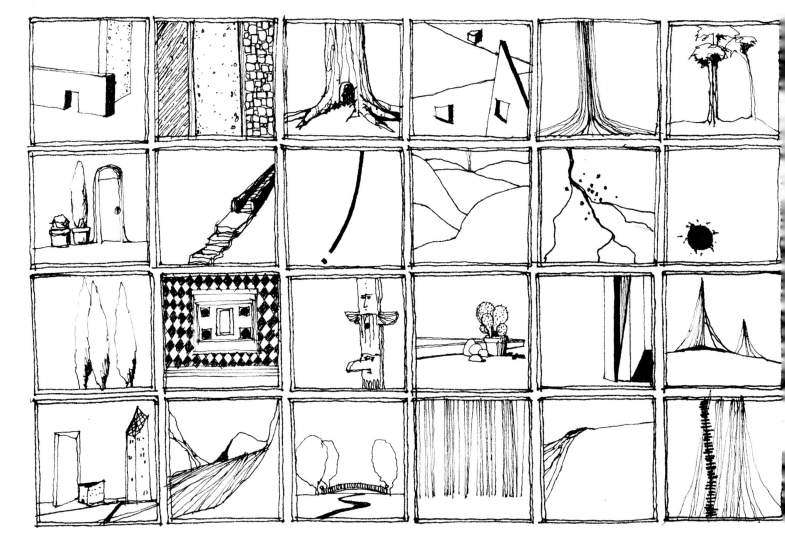

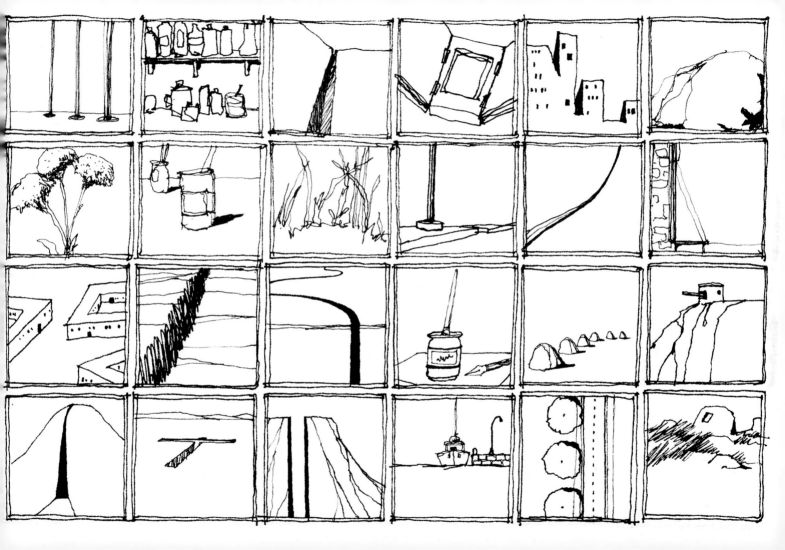

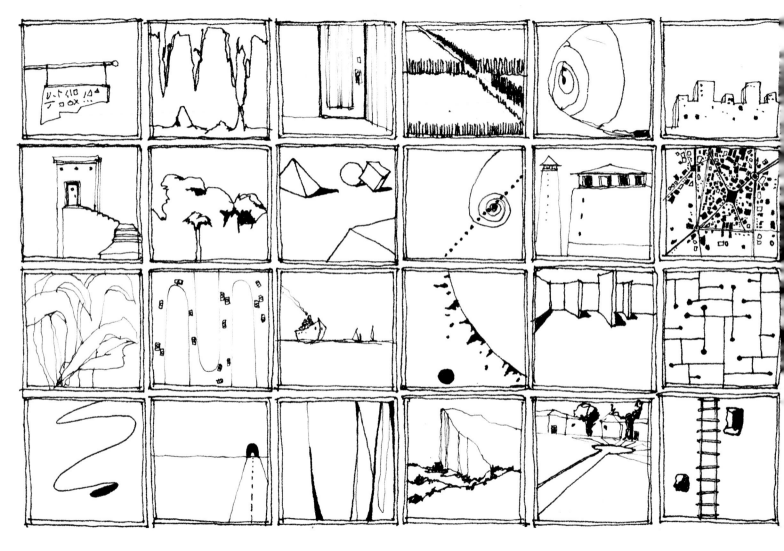

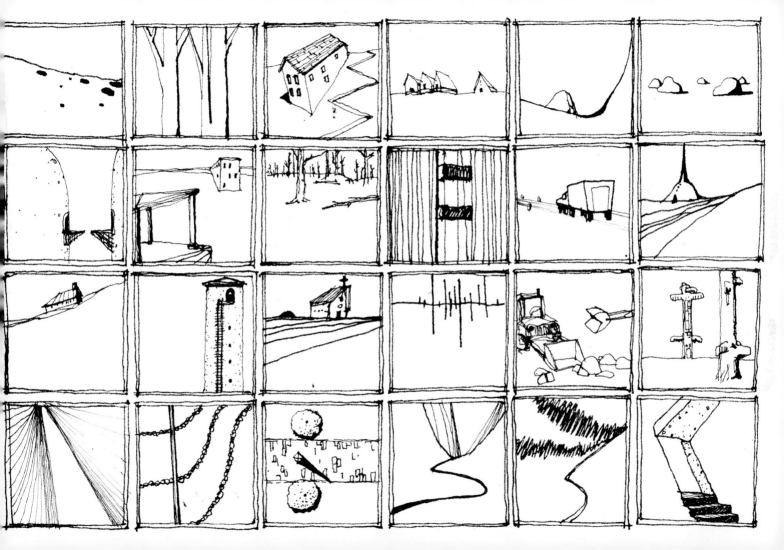

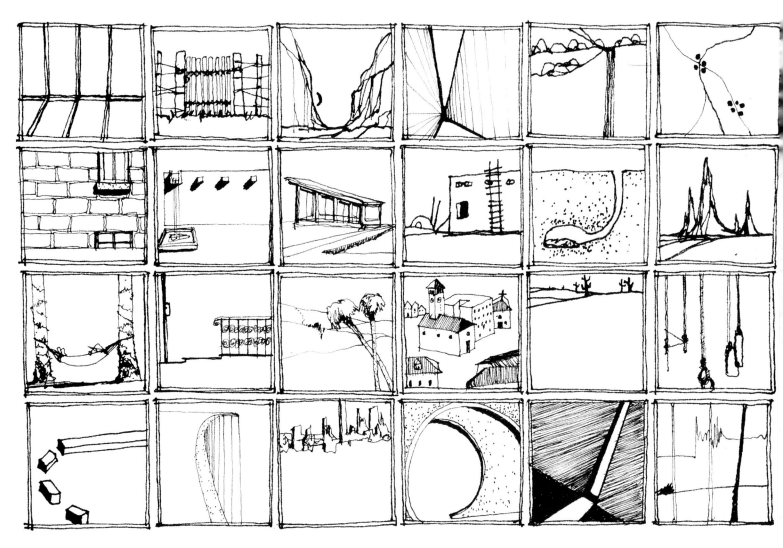

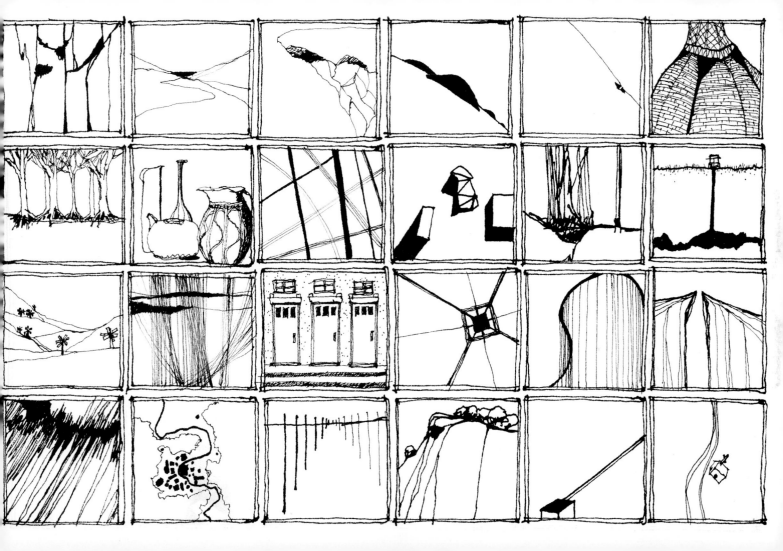

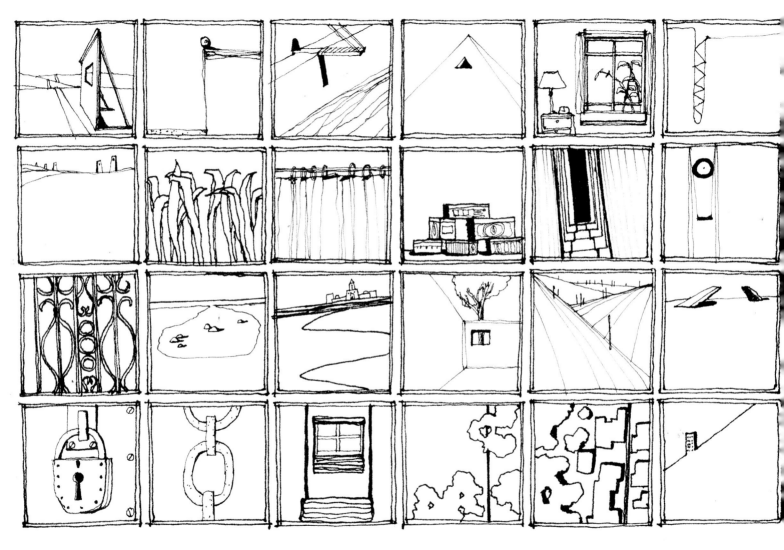

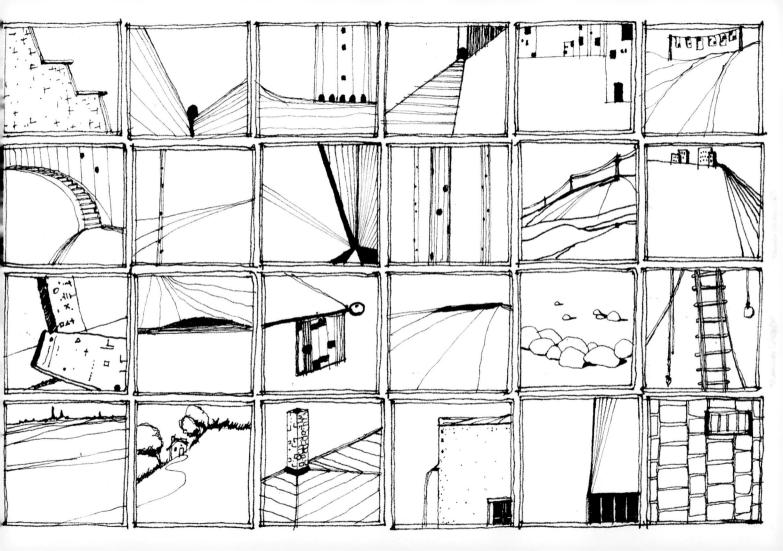

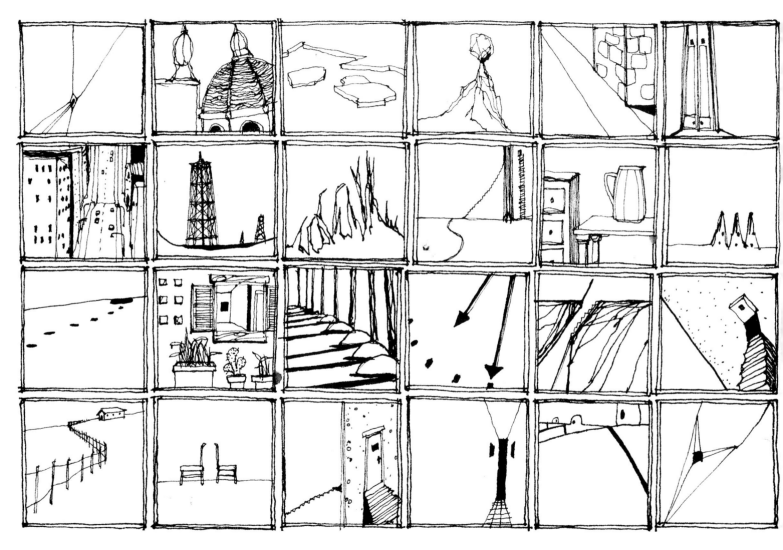

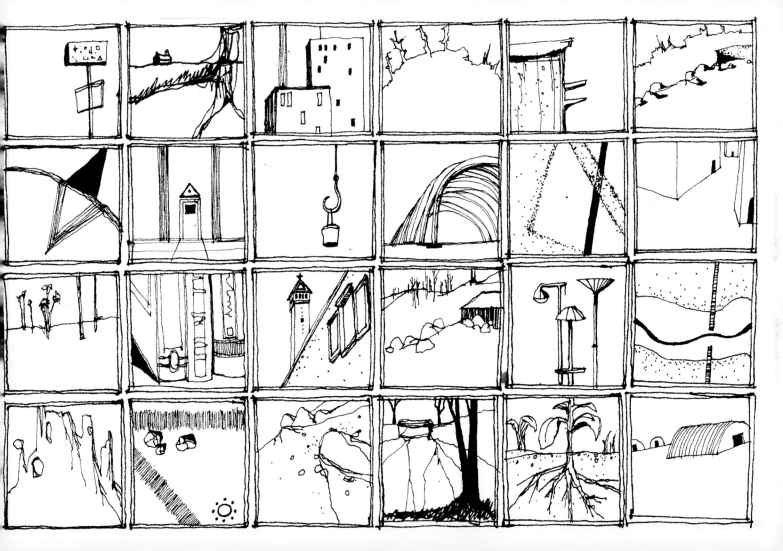

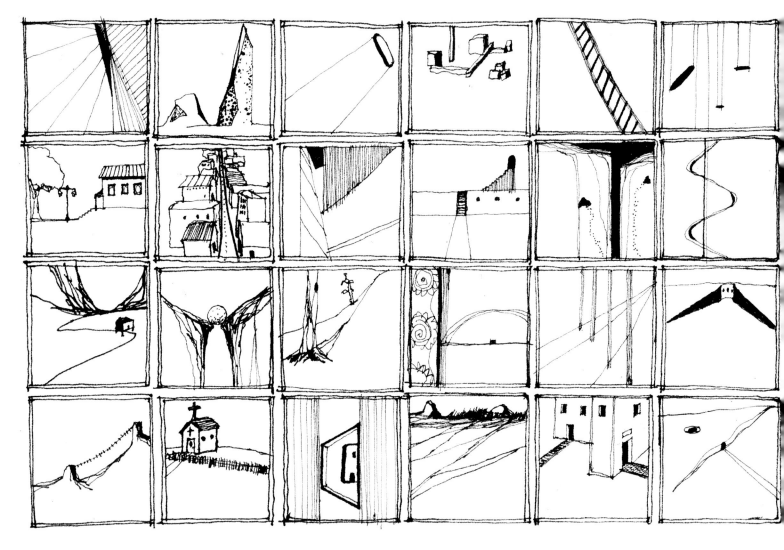

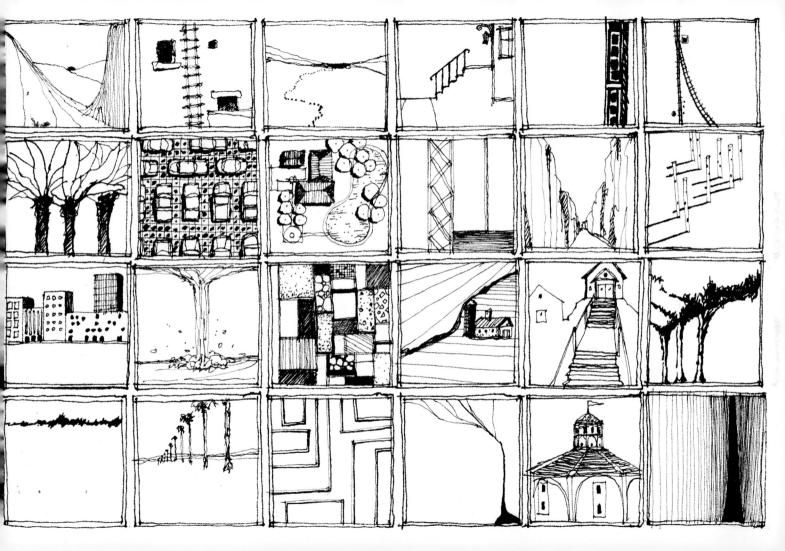

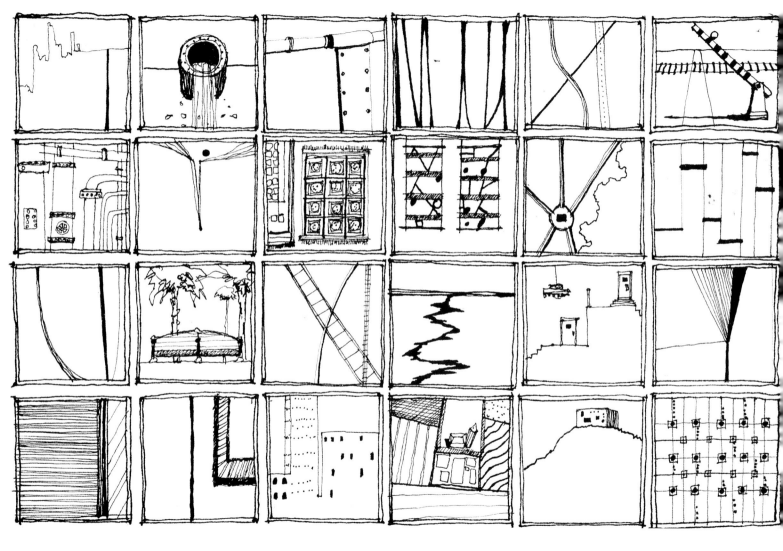

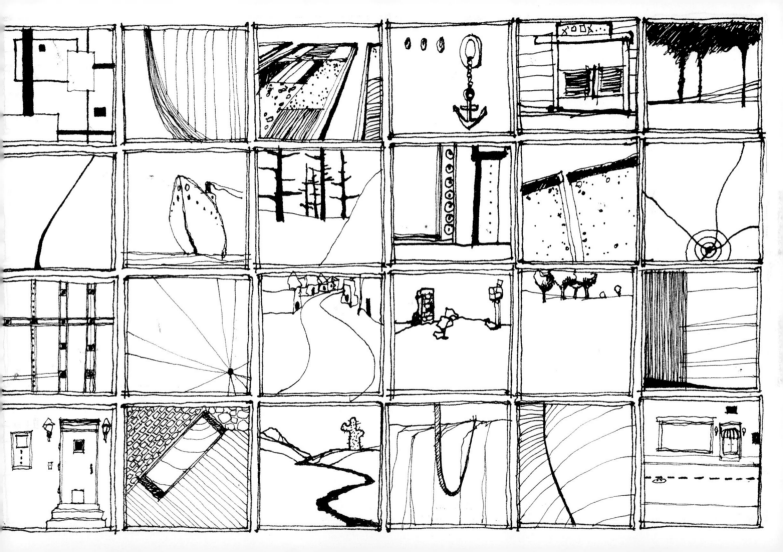

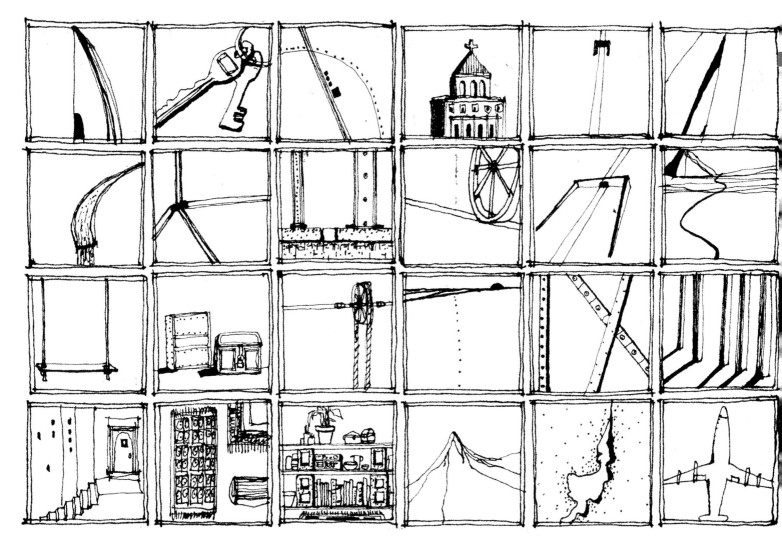

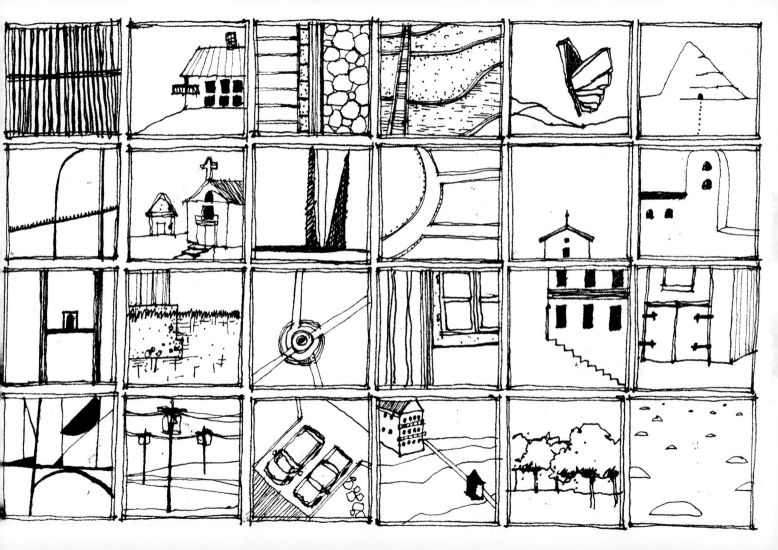

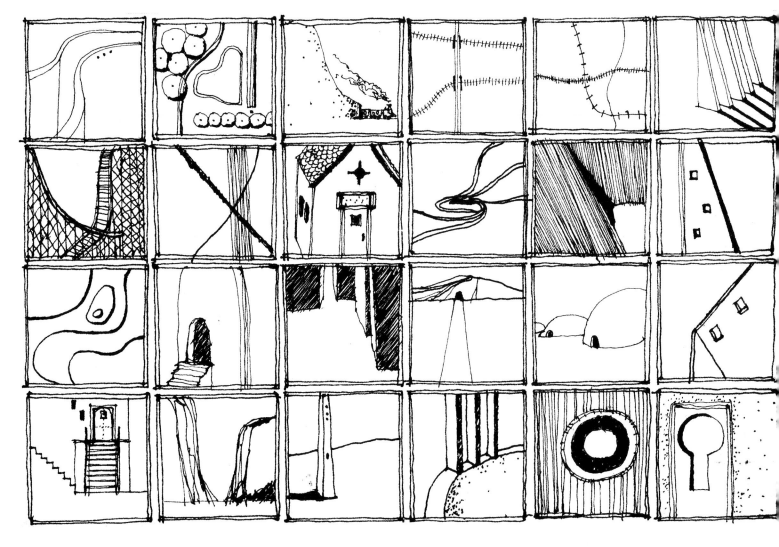

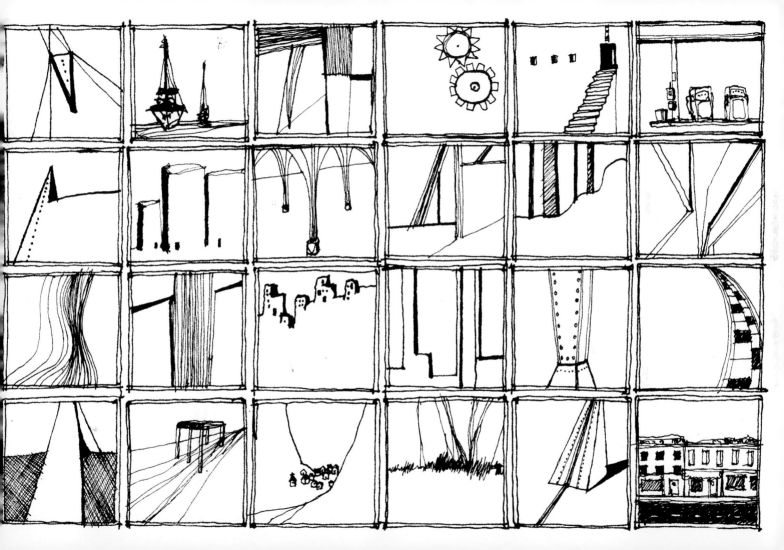

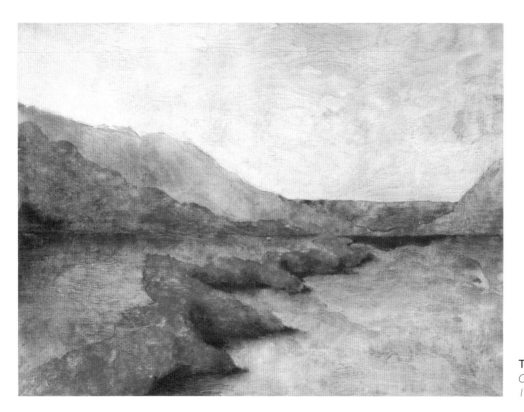

Tennessee Valley
Charcoal, pastel, watercolor, and gouache on plywoo
18"x24"

Landscapes

Simple forms in the landscape are often profound and powerful.

Their simplicity allows for an economy of line and use of negative space, which makes for compelling imagery.

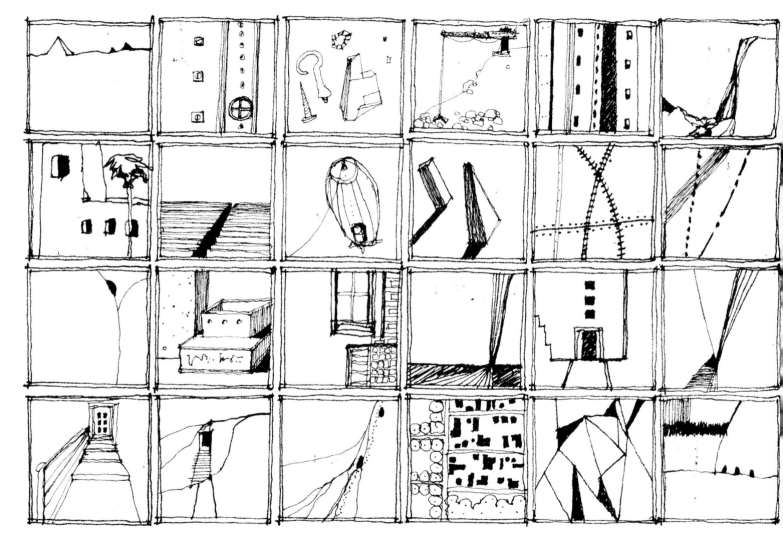

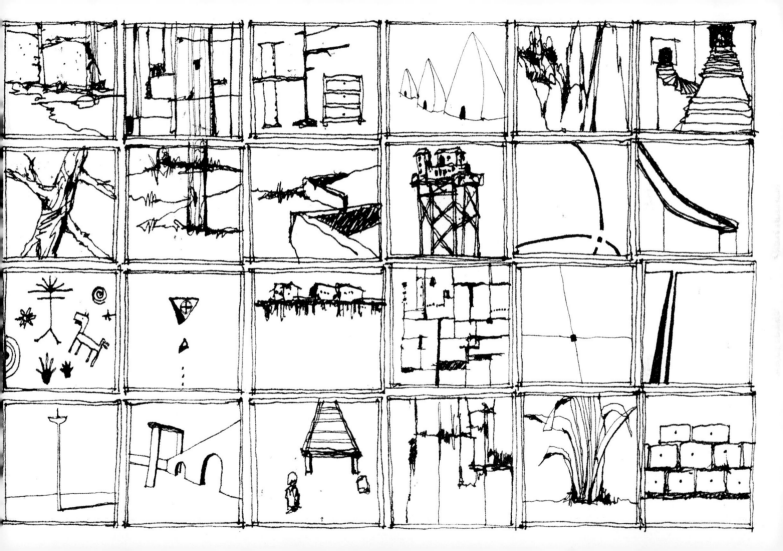

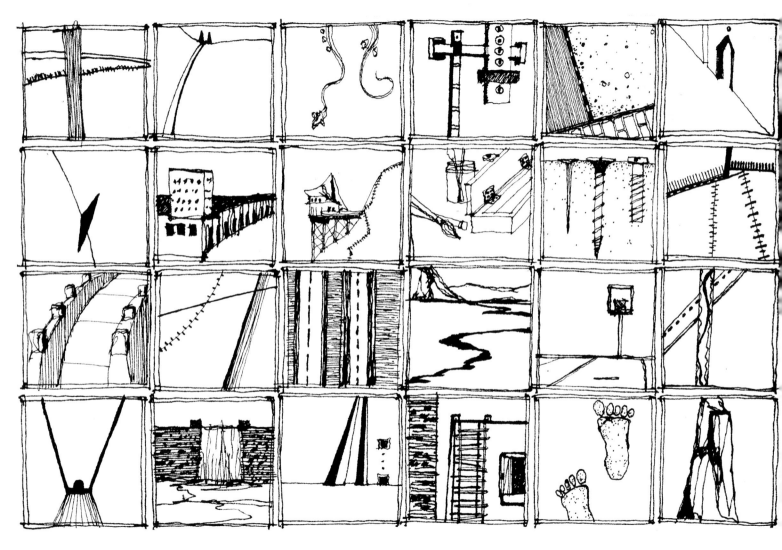

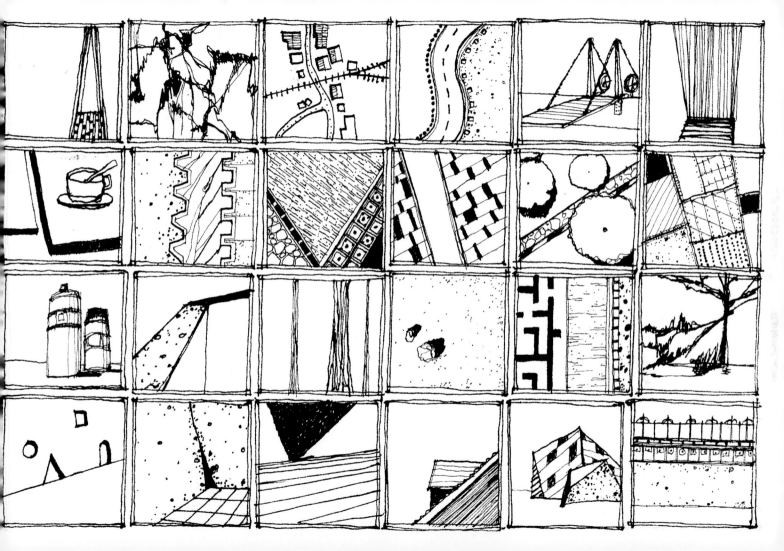

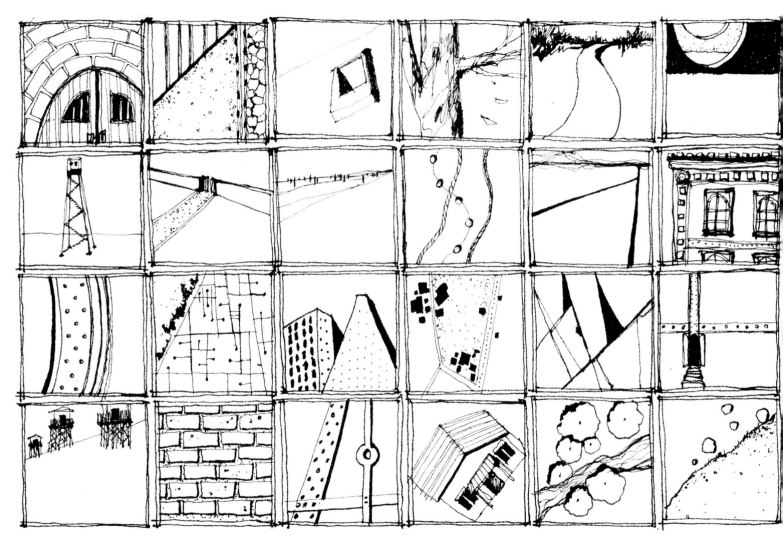

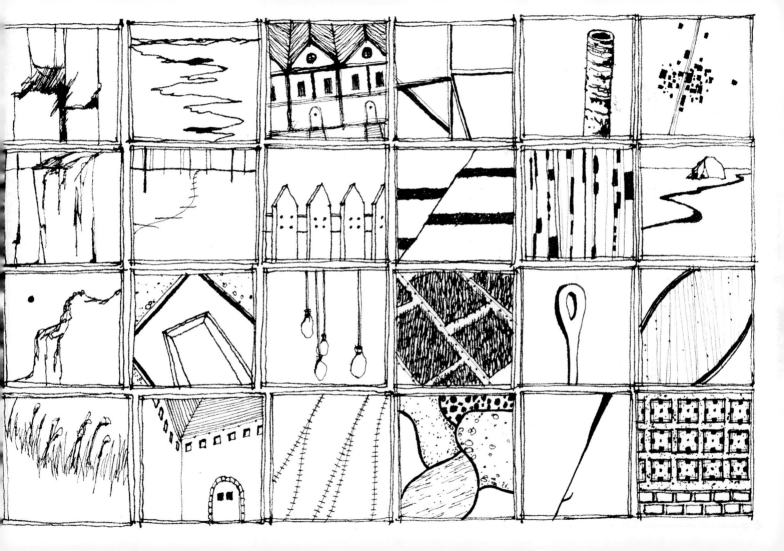

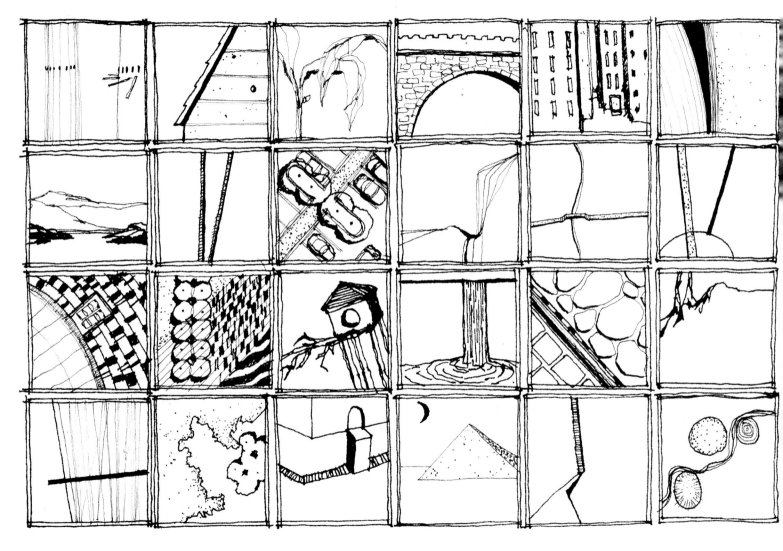

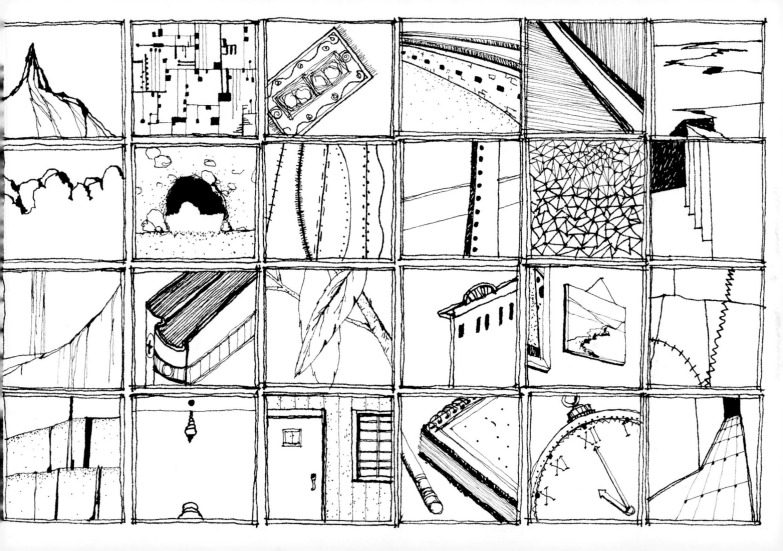

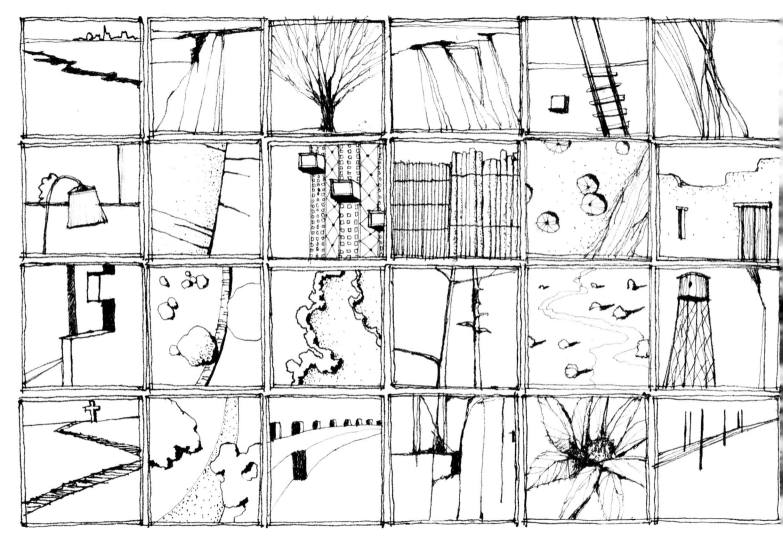

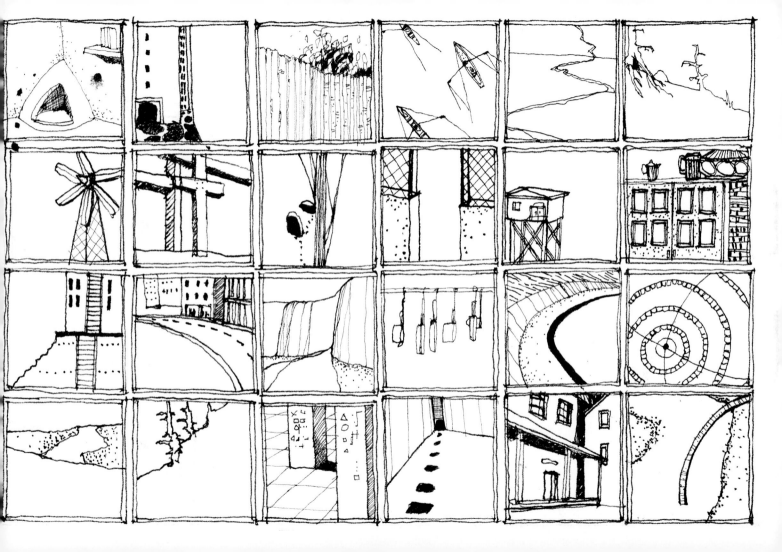

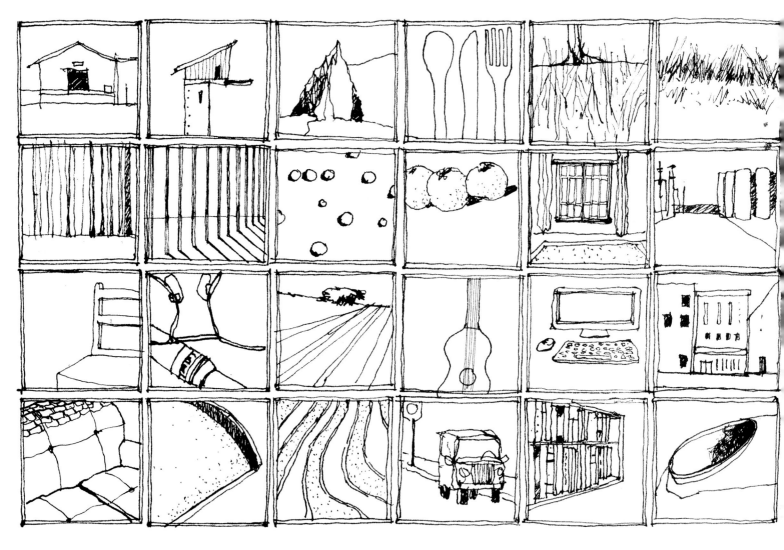

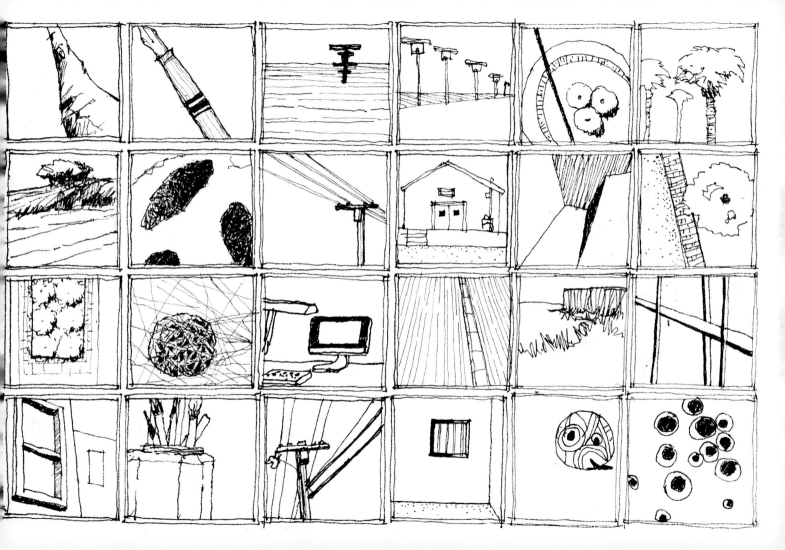

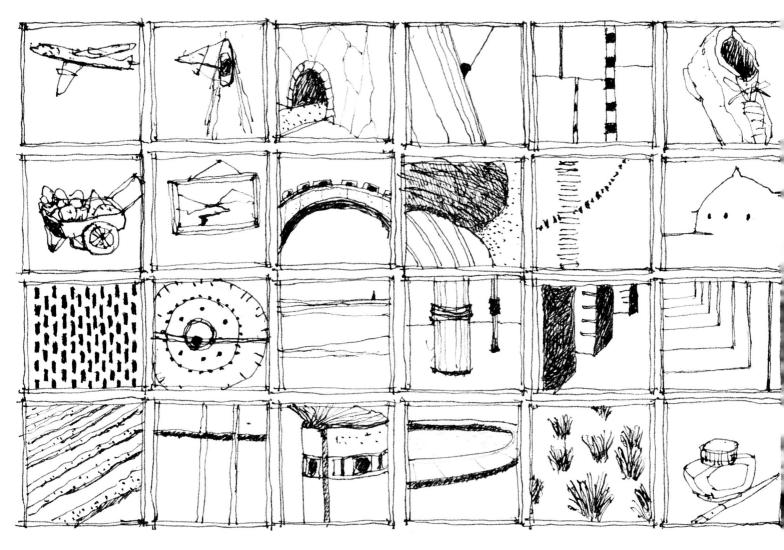

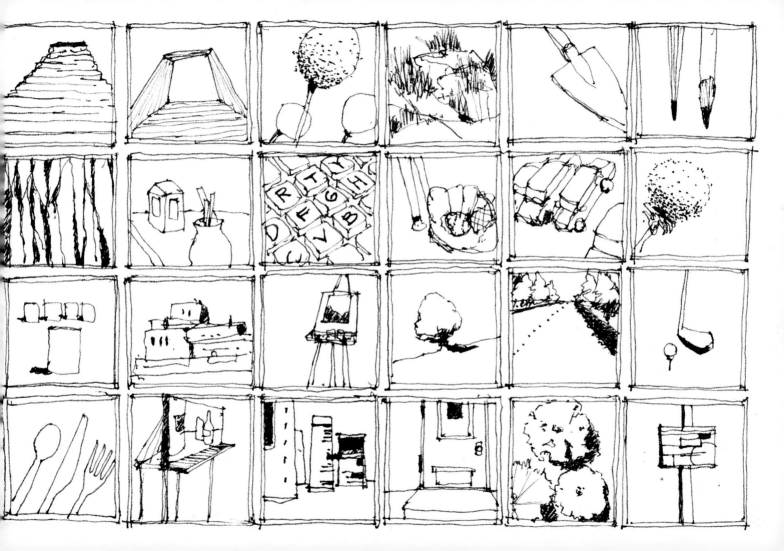

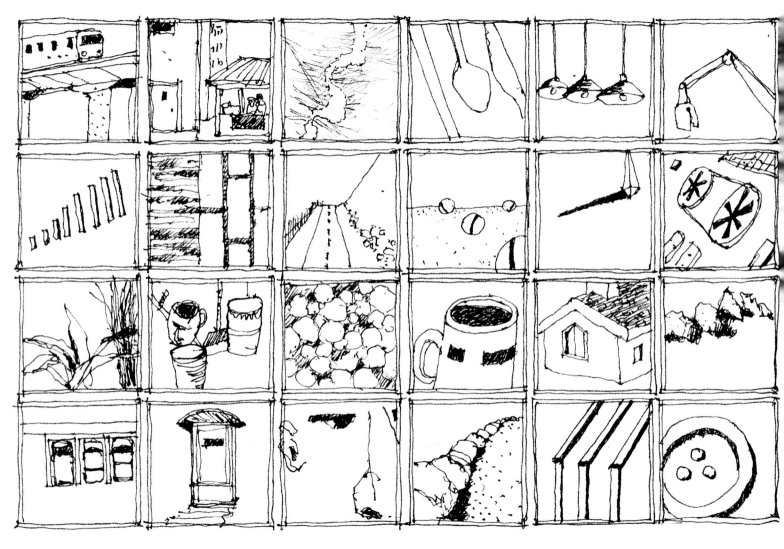

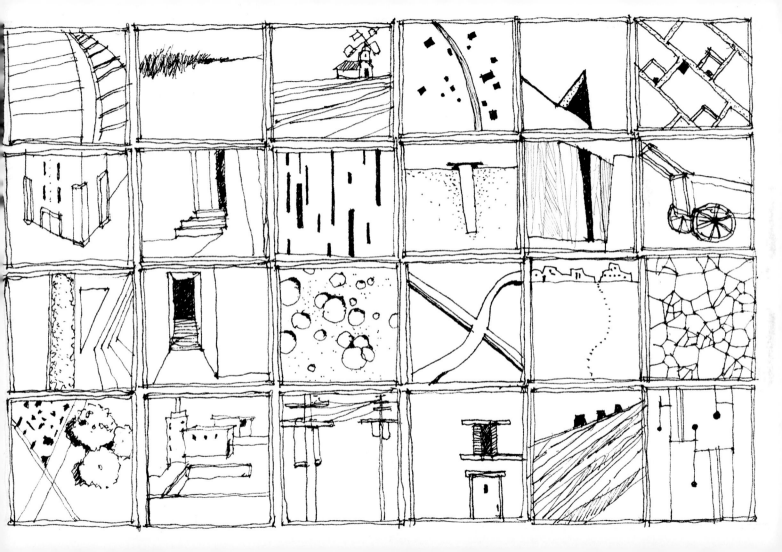

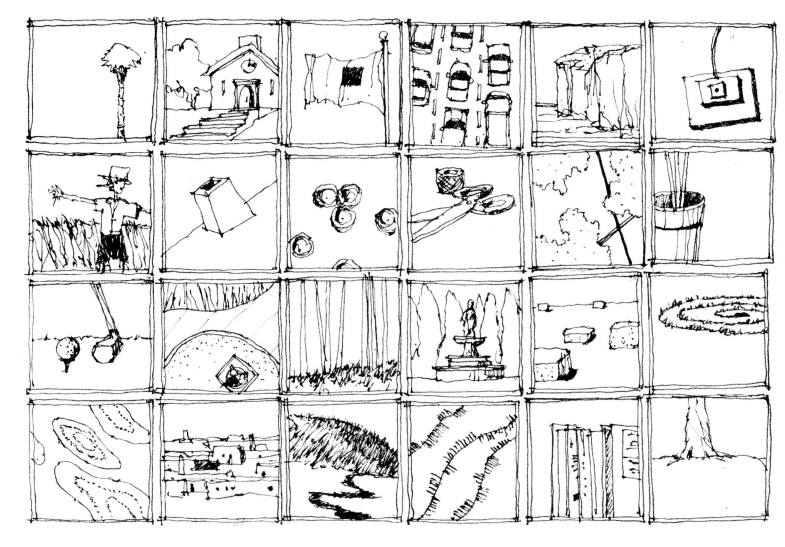

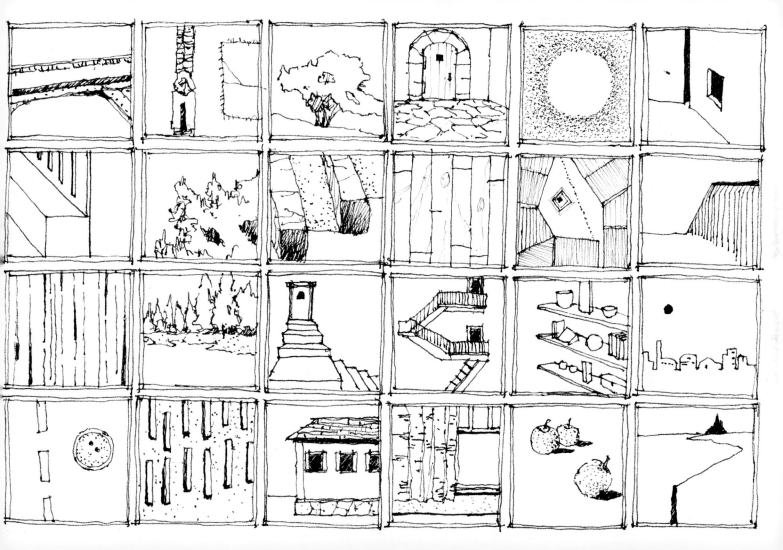

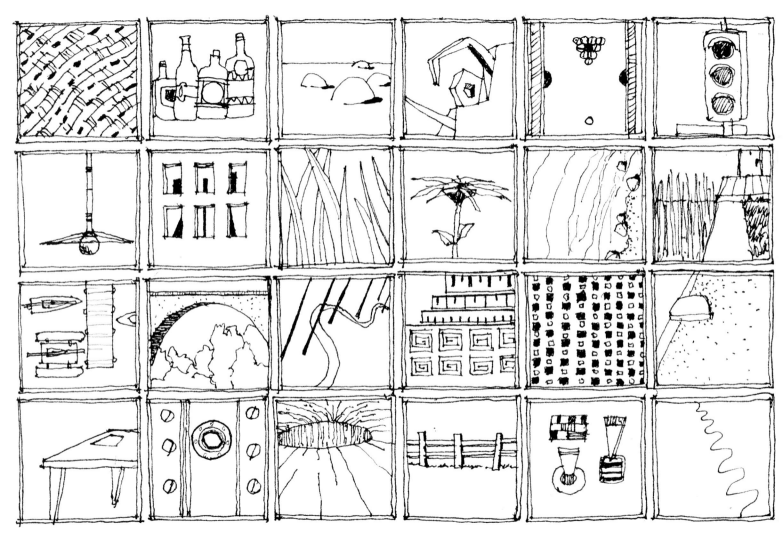

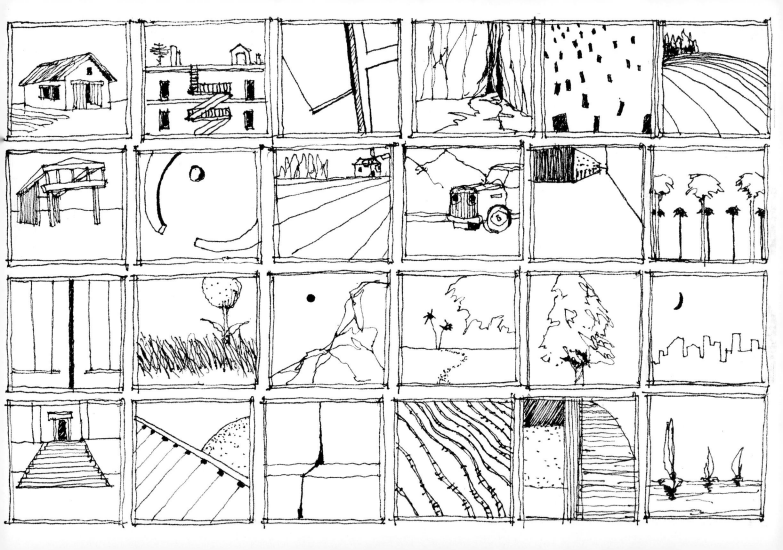

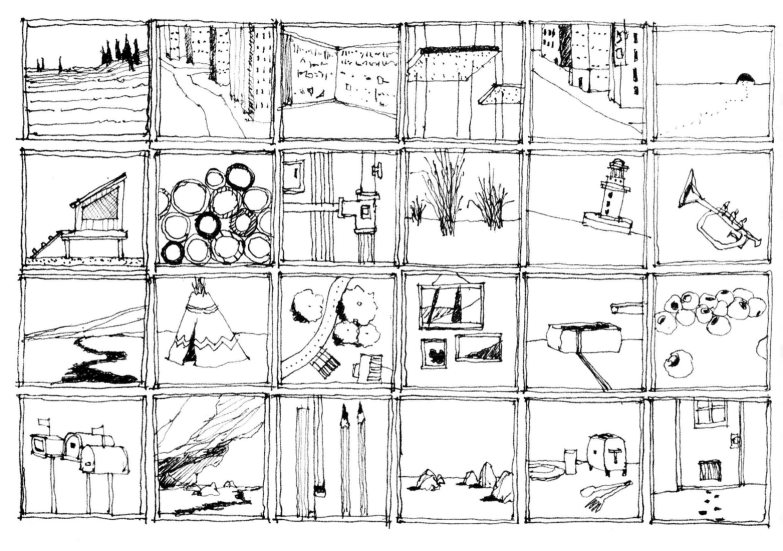

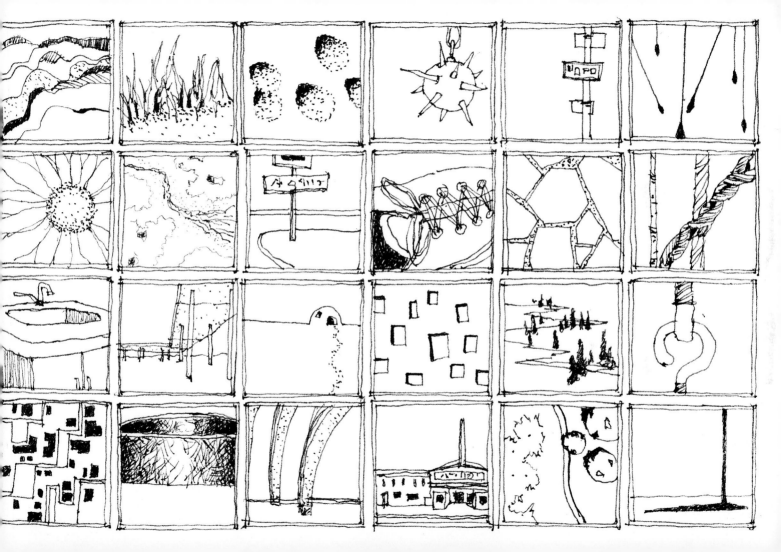

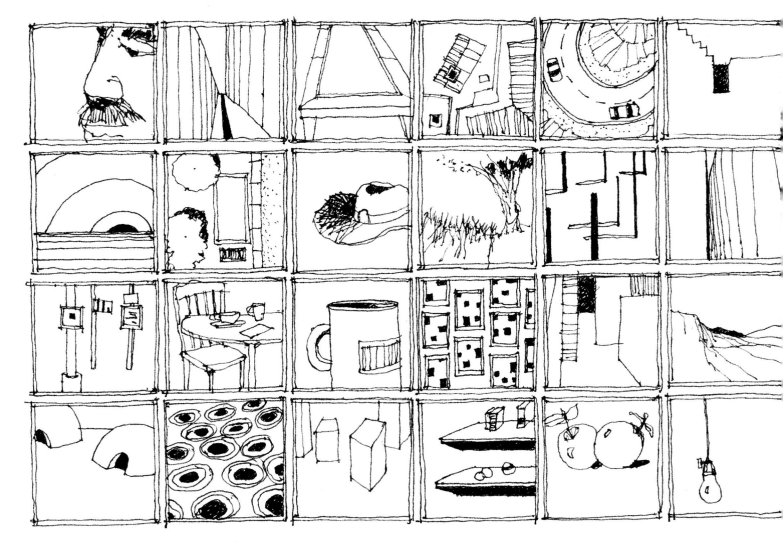

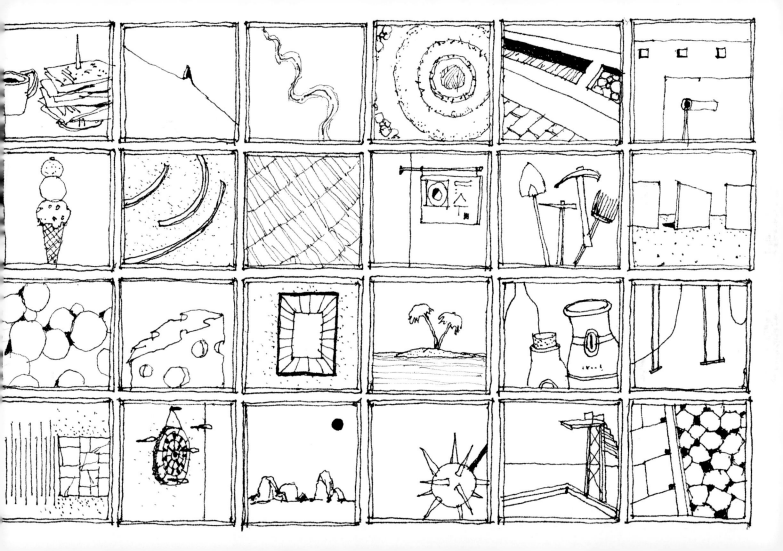

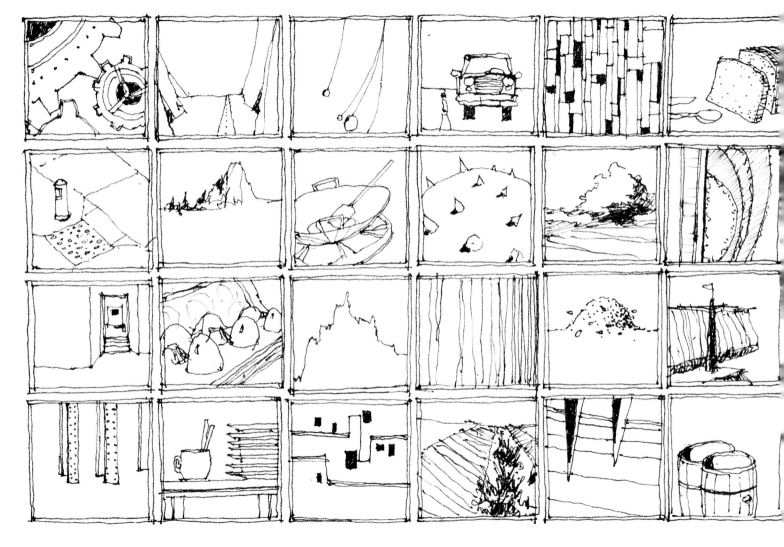

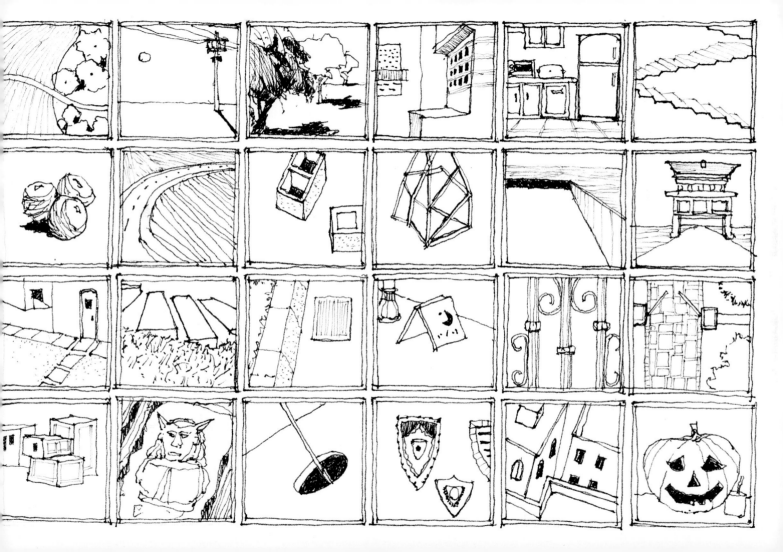

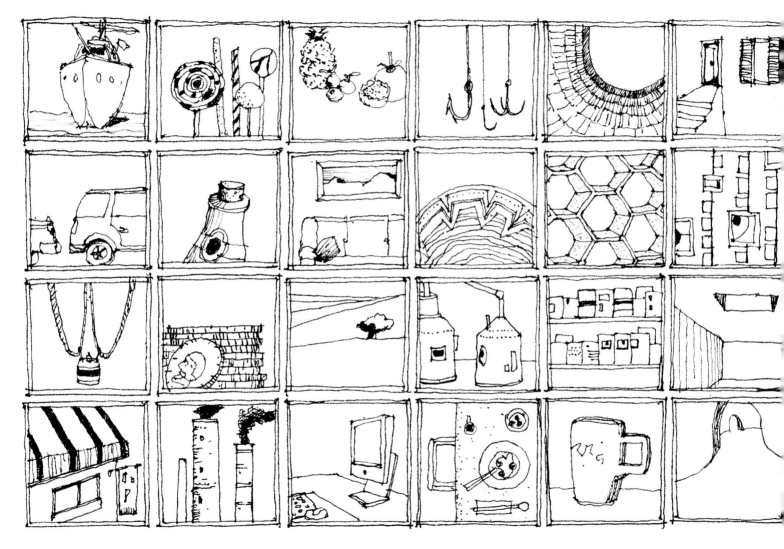

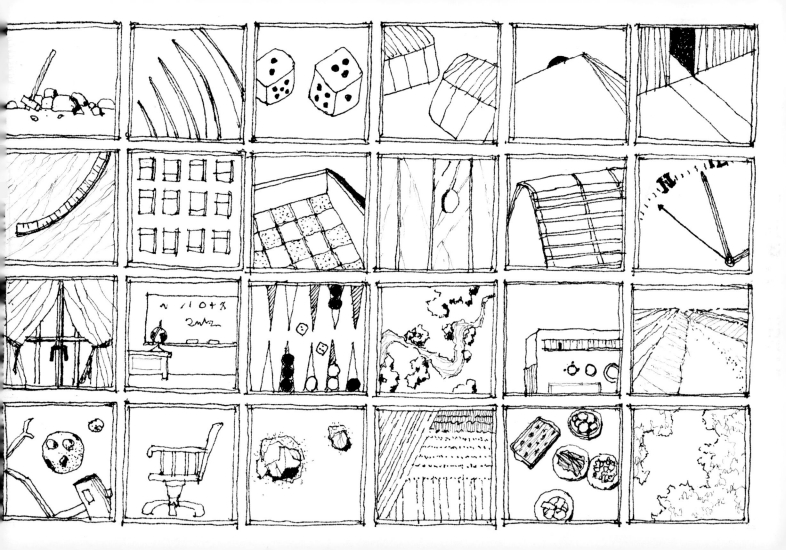

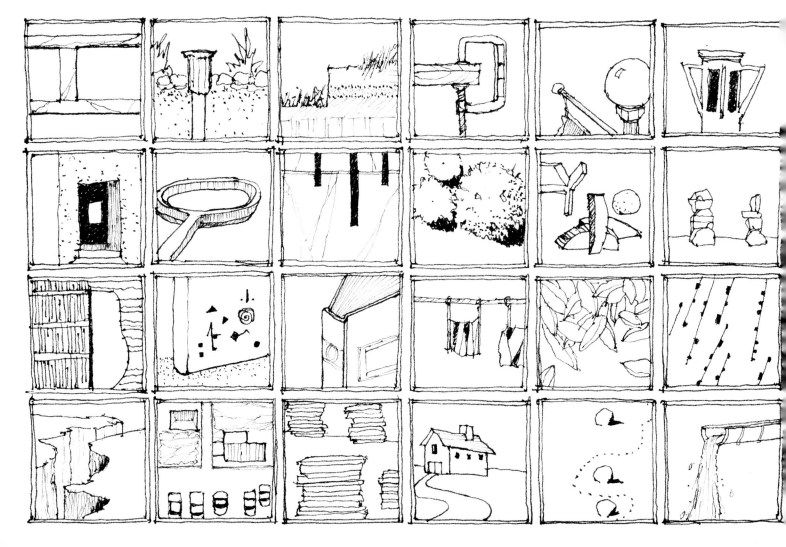

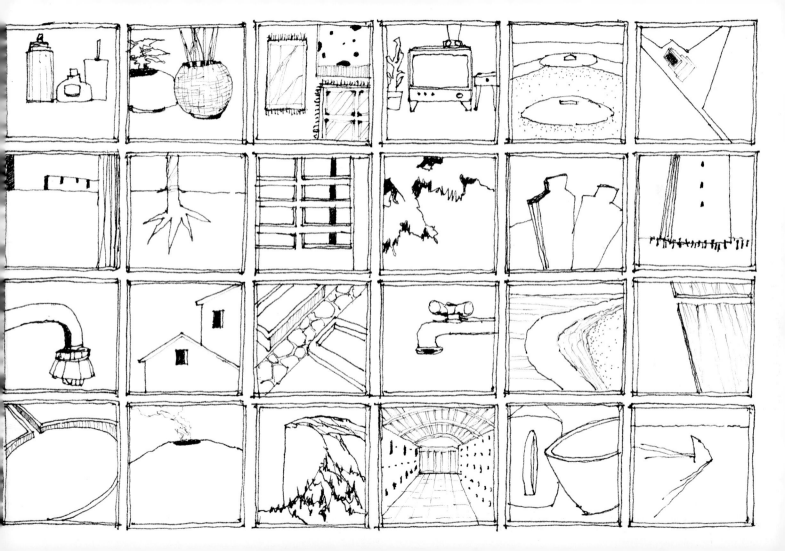

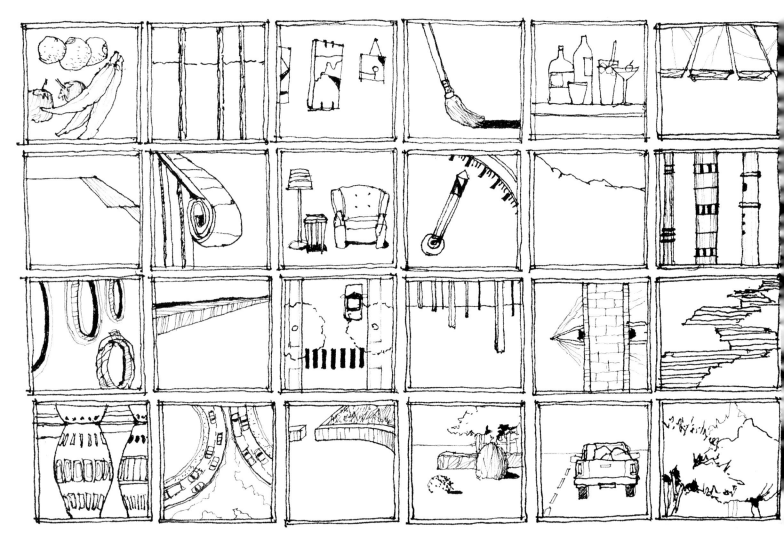

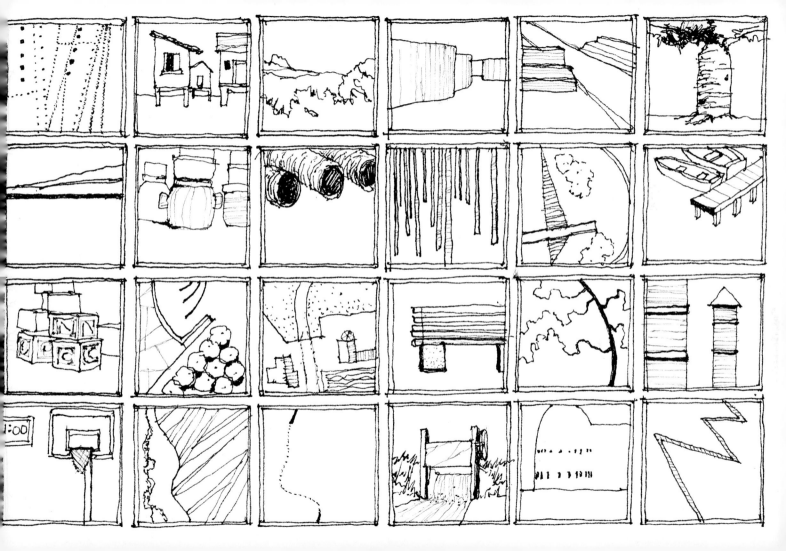

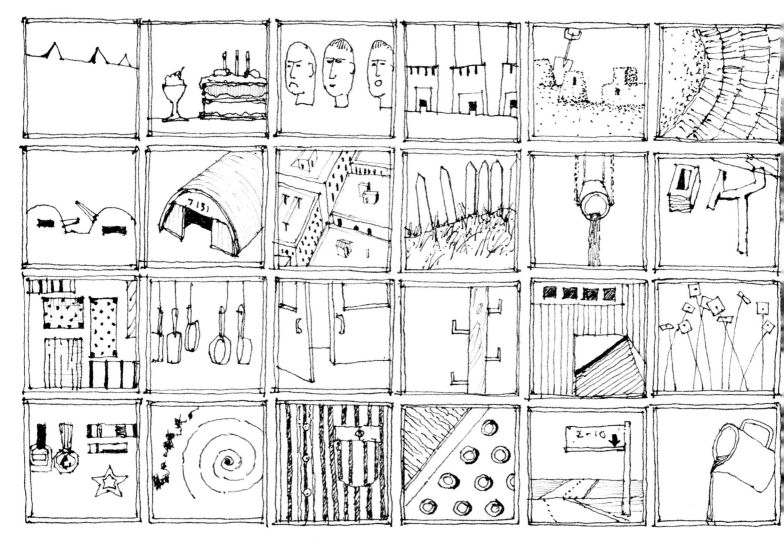

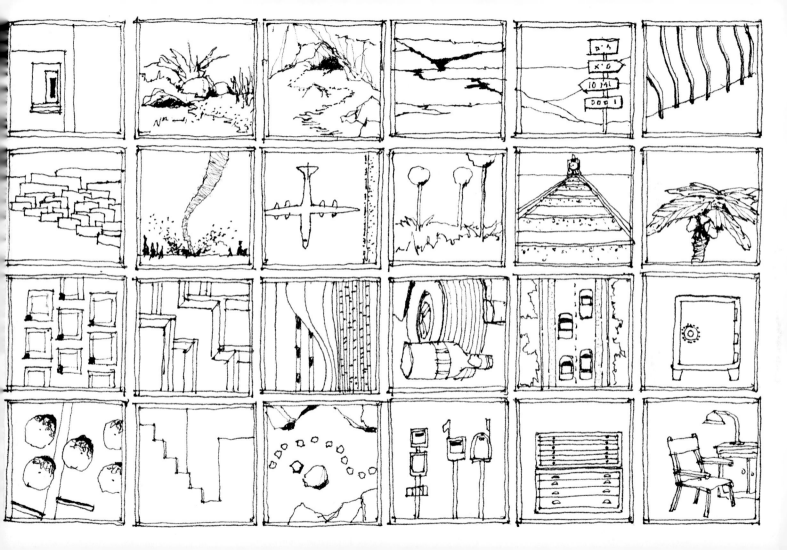

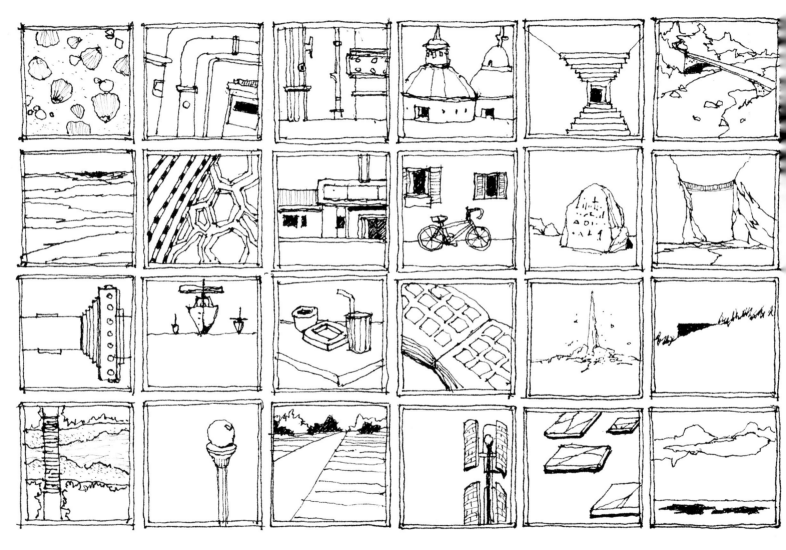

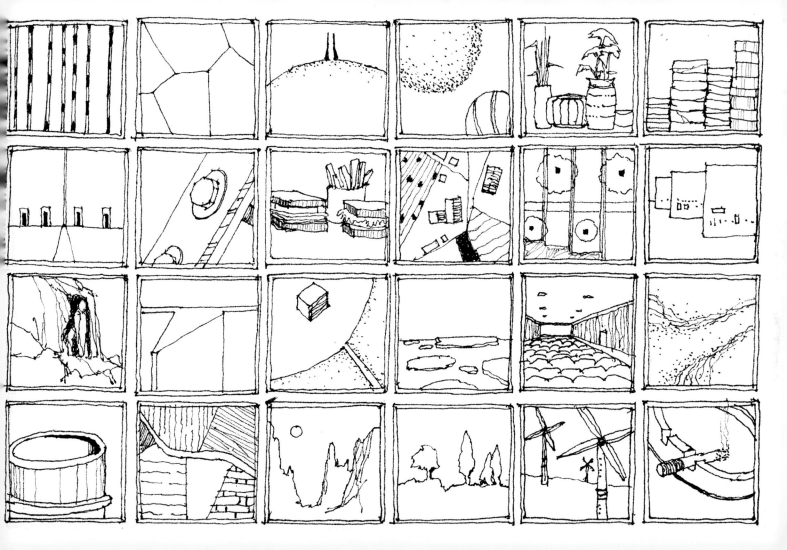

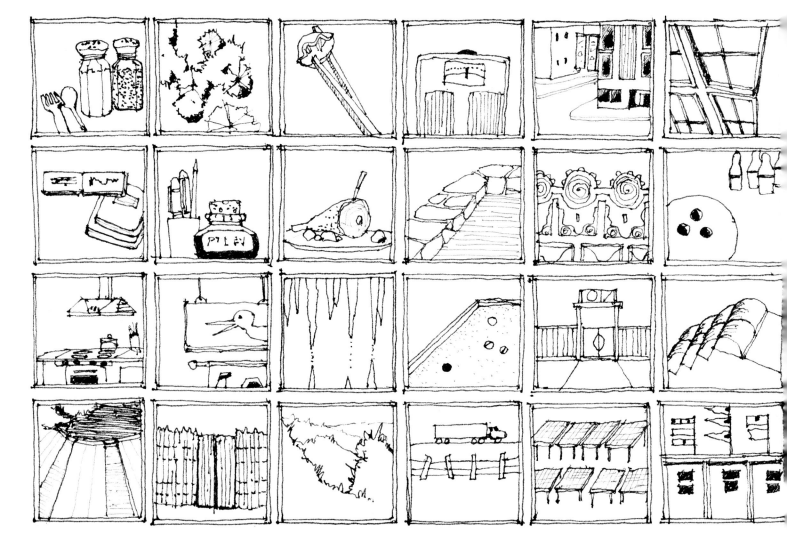

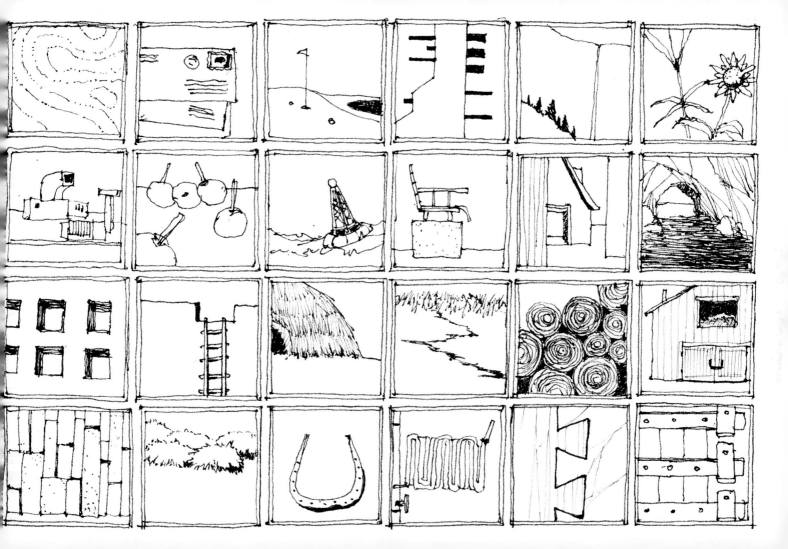

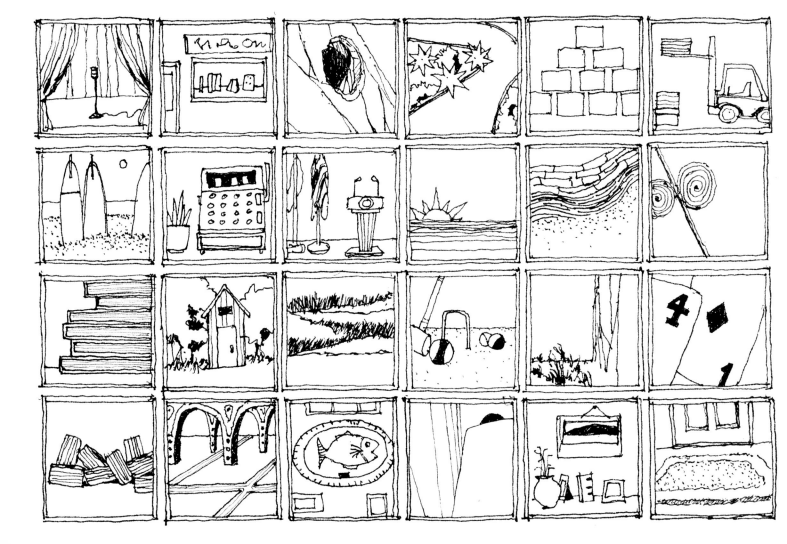

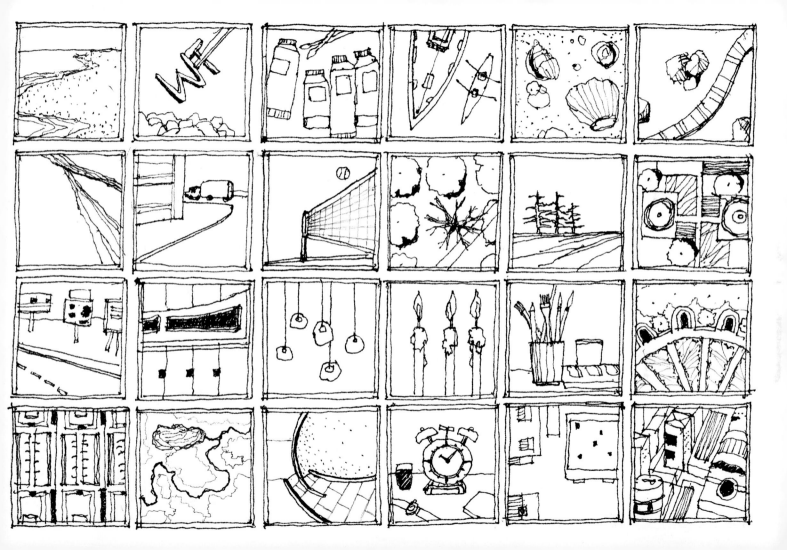

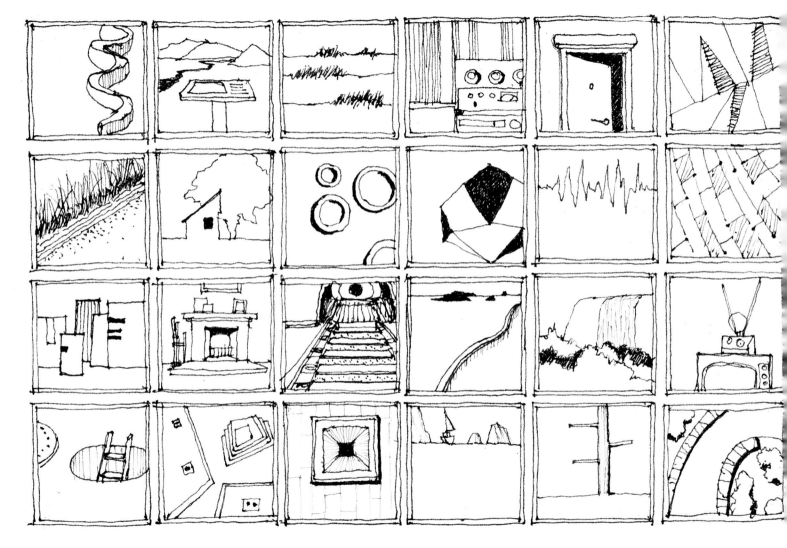

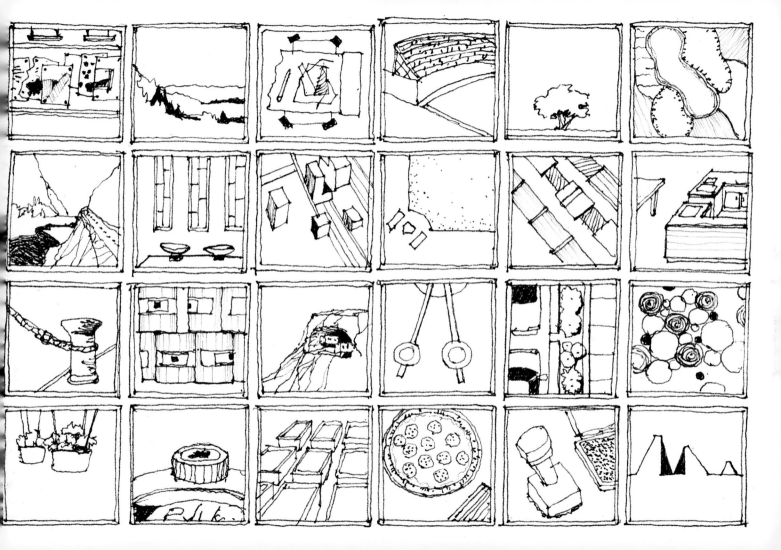

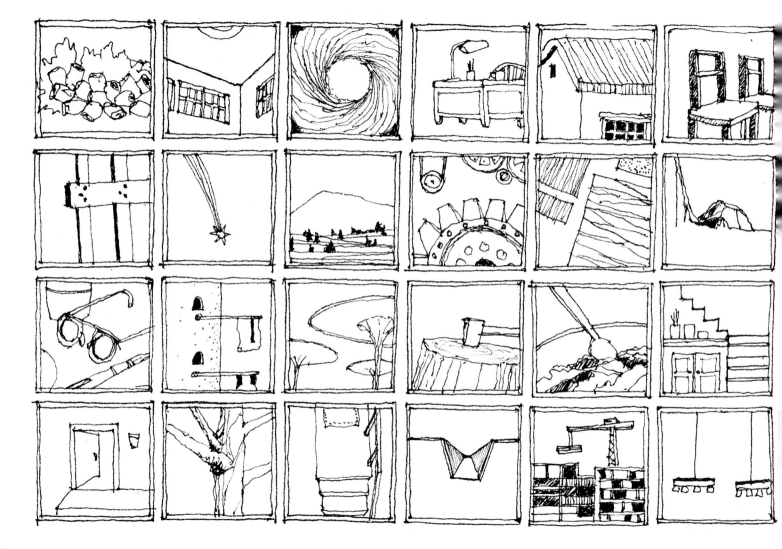

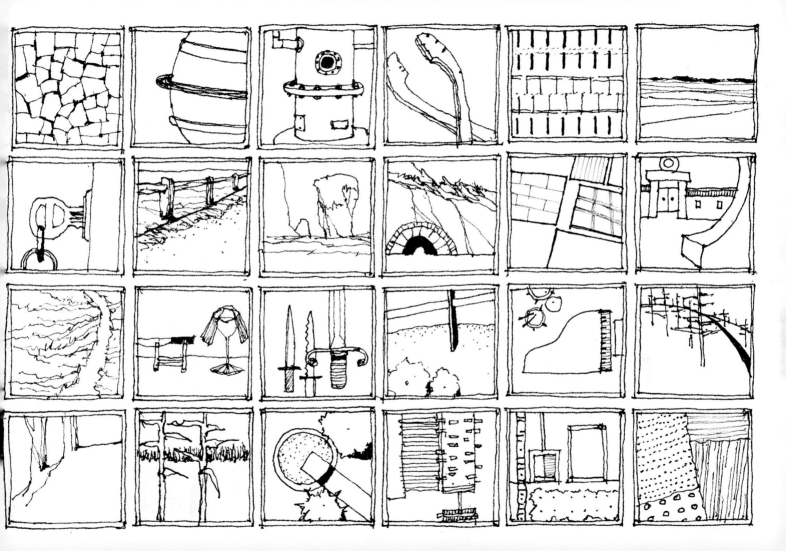

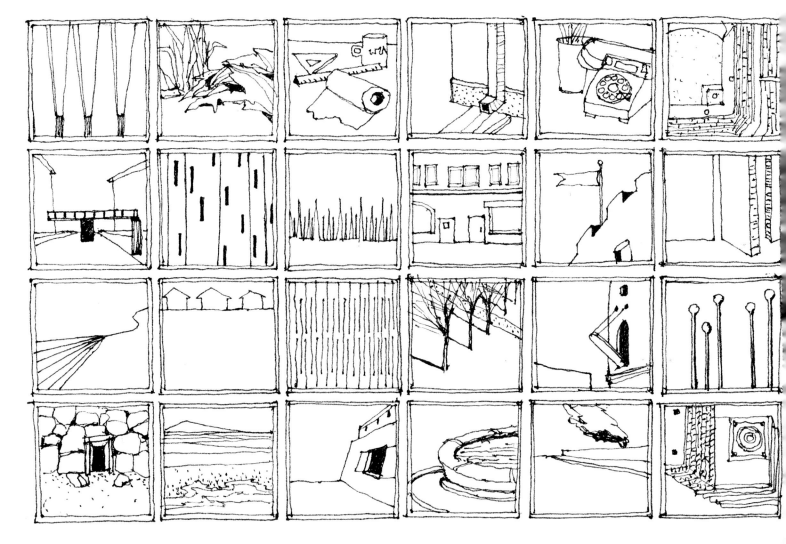

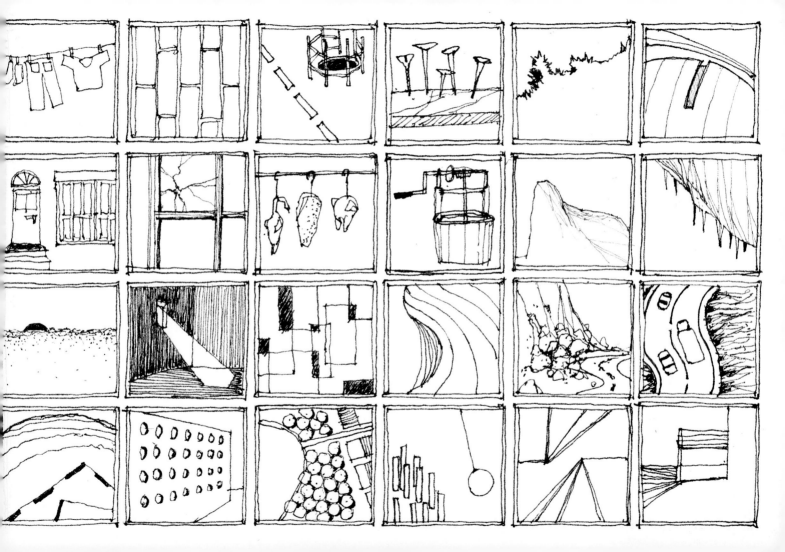

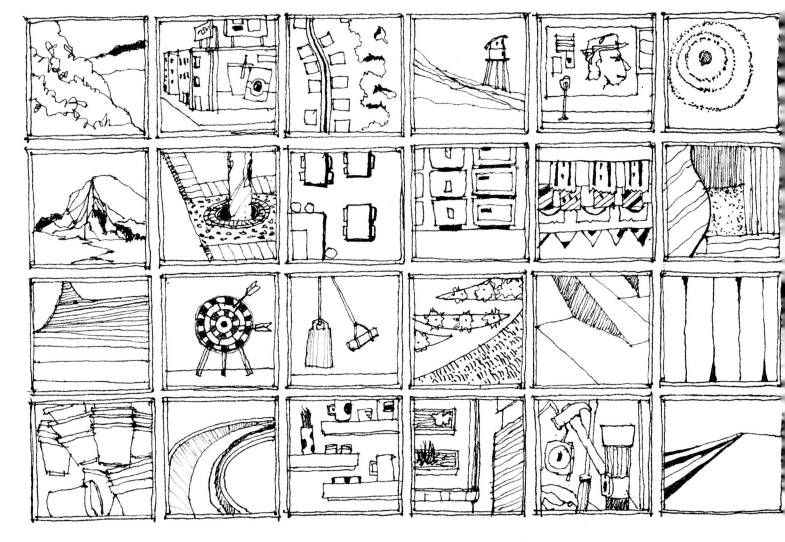

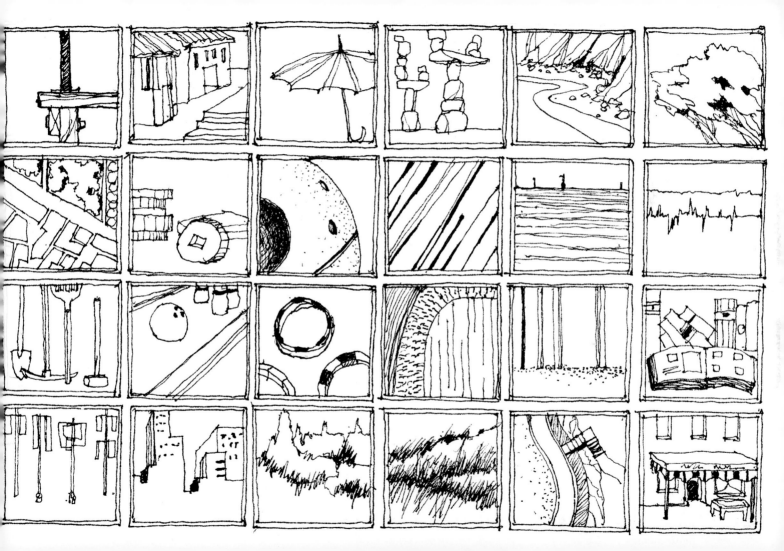

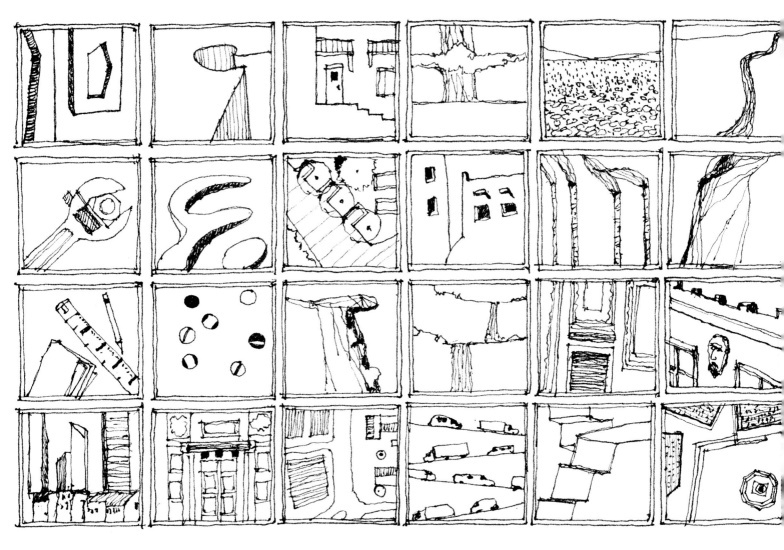

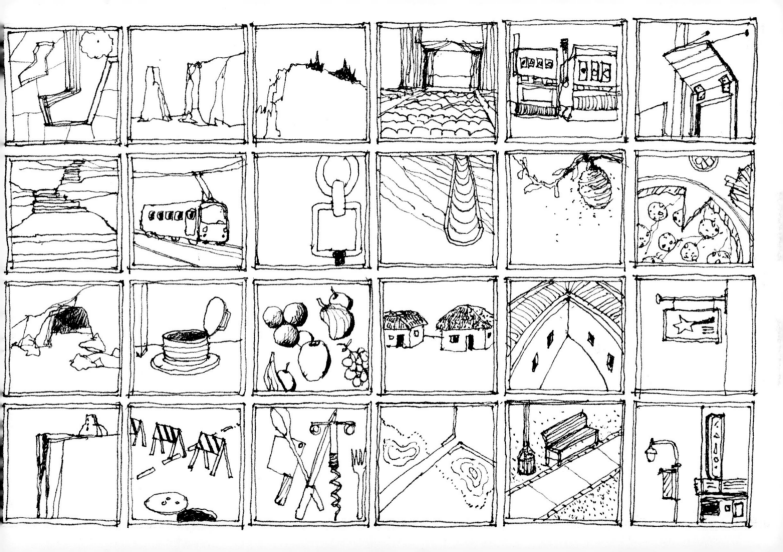

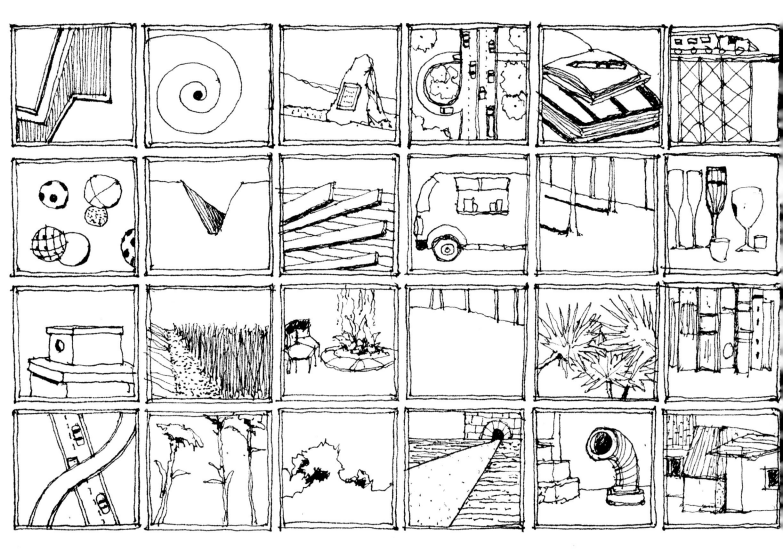

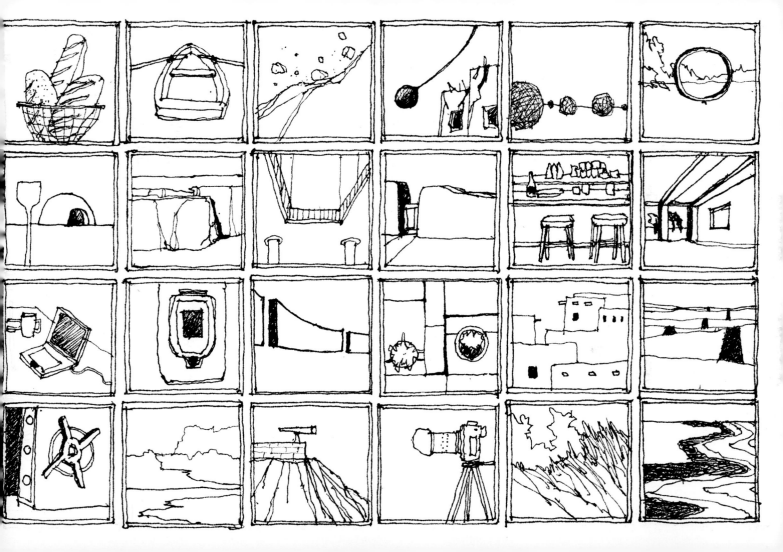

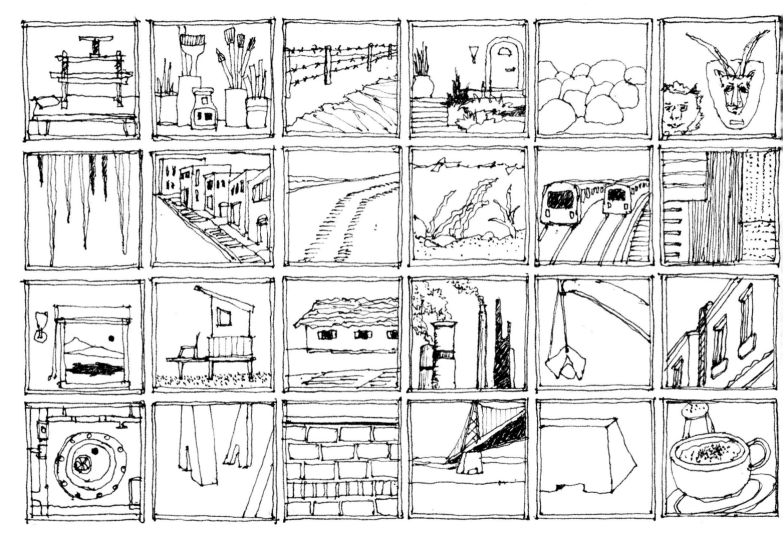

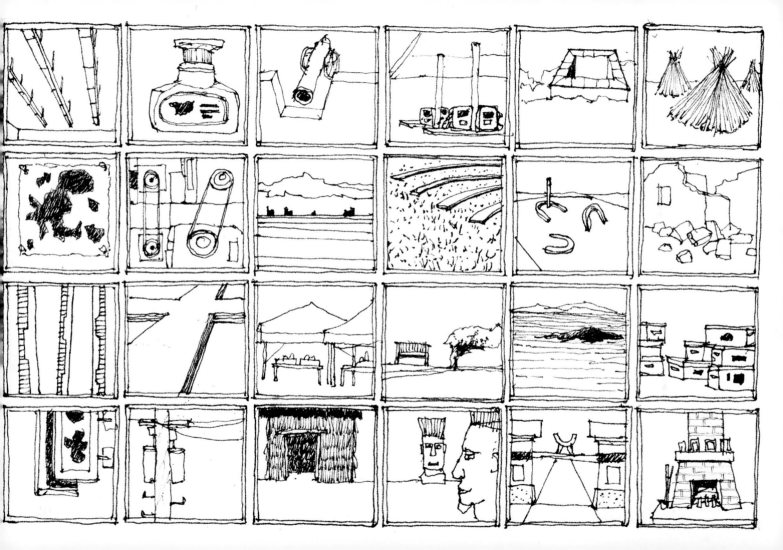

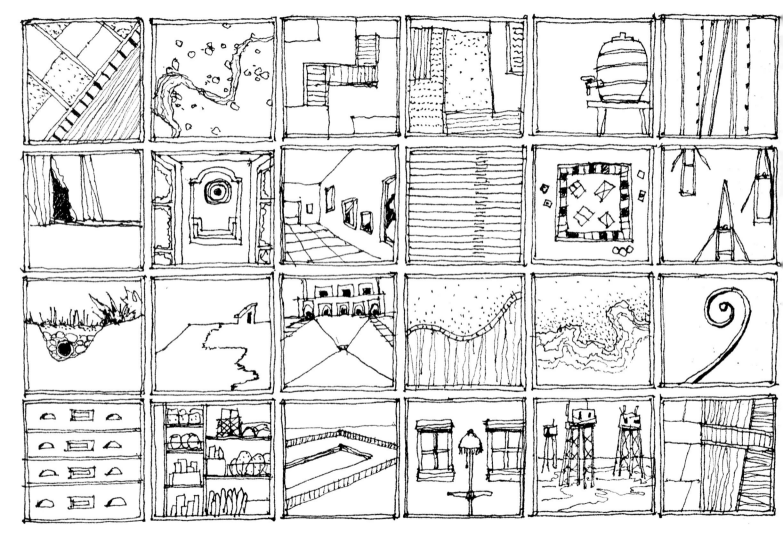

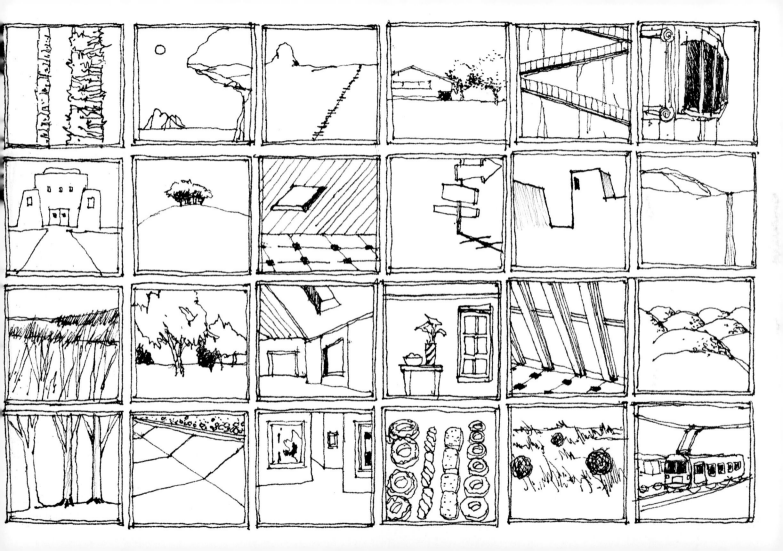

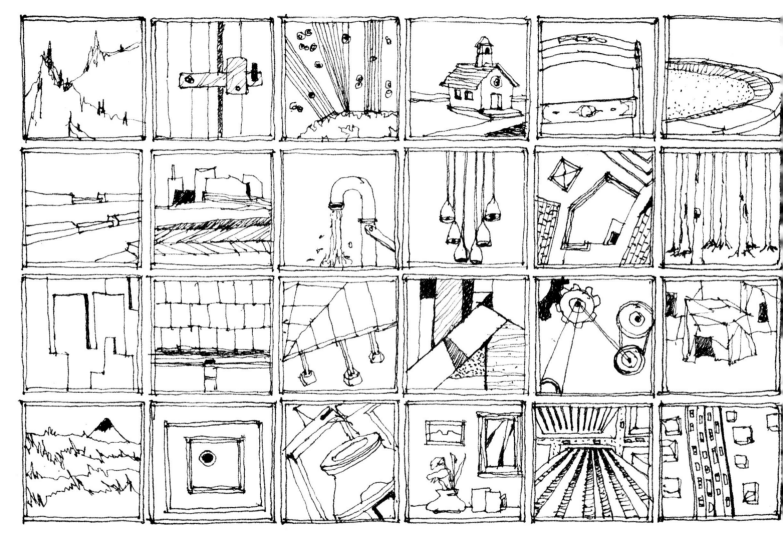

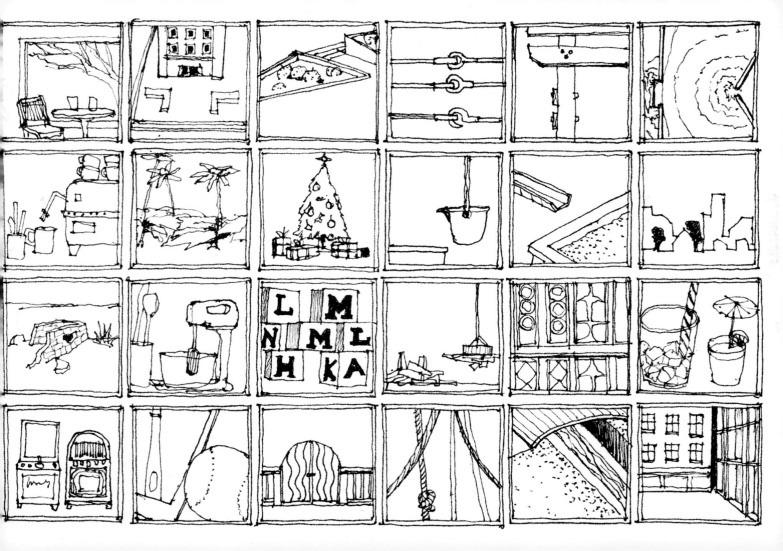

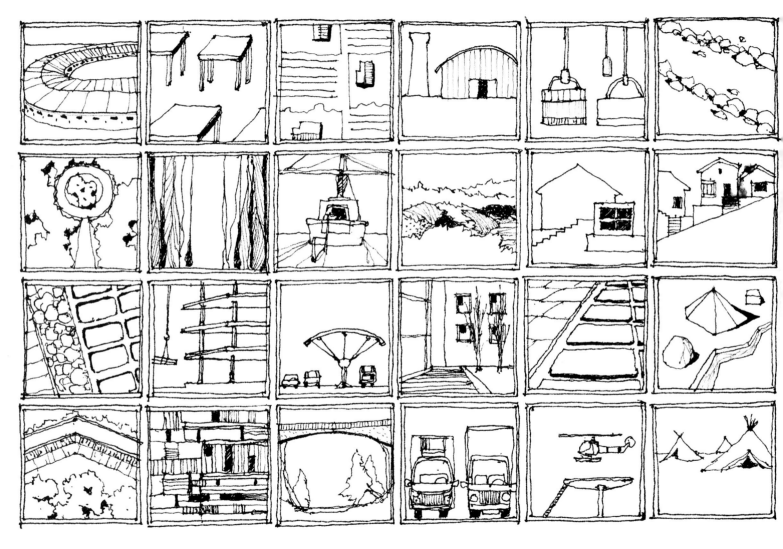

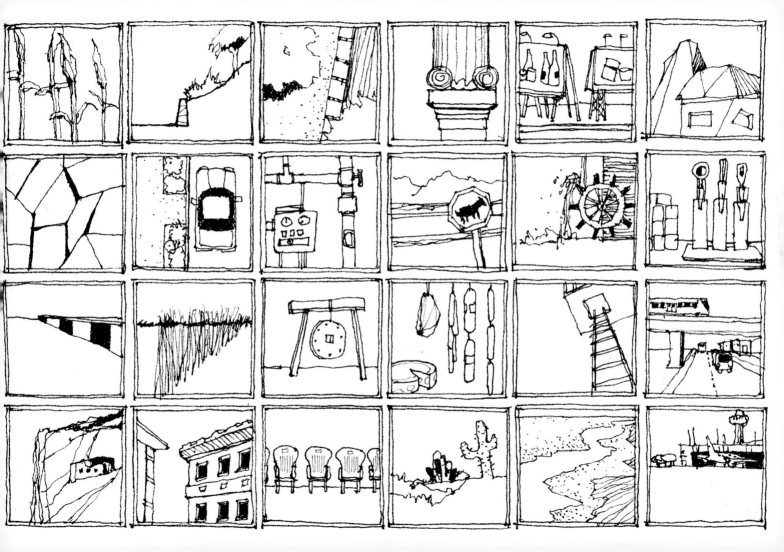

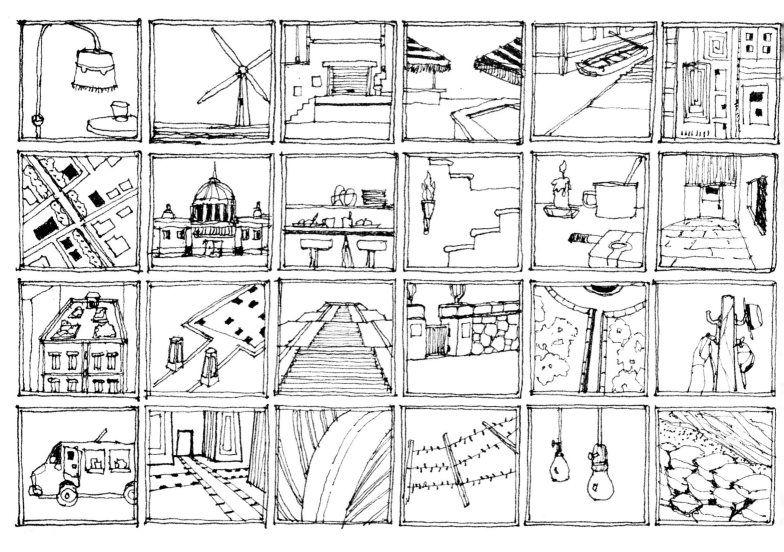

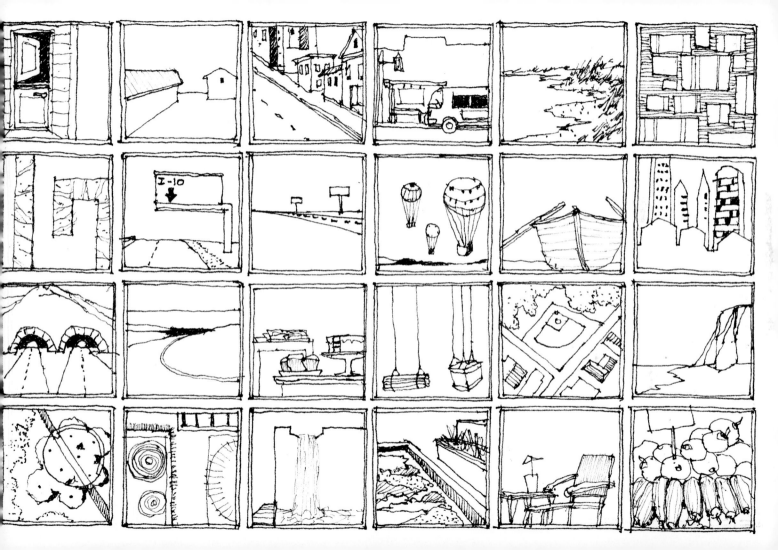

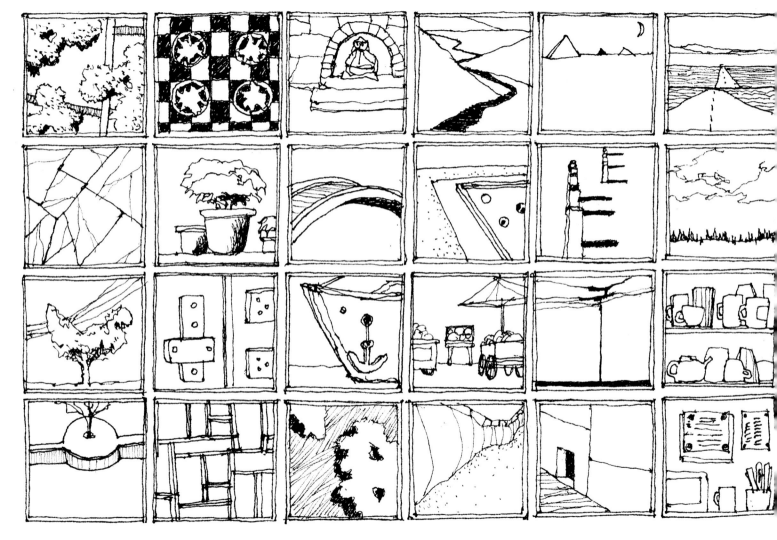

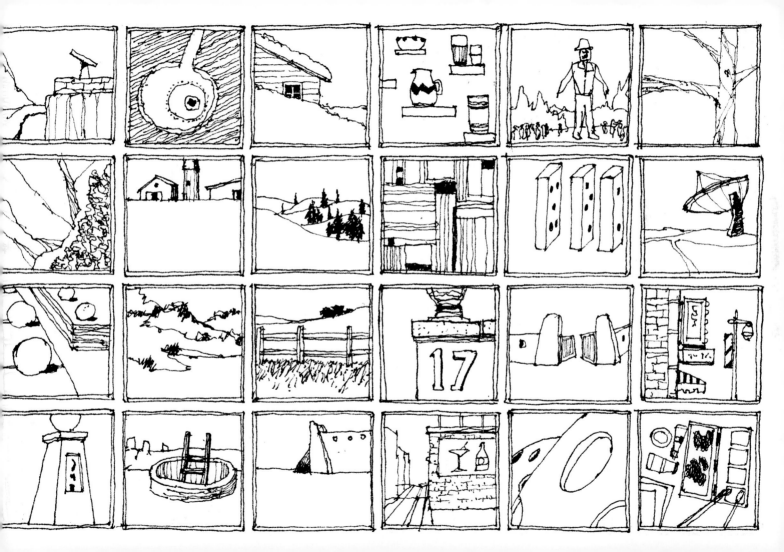

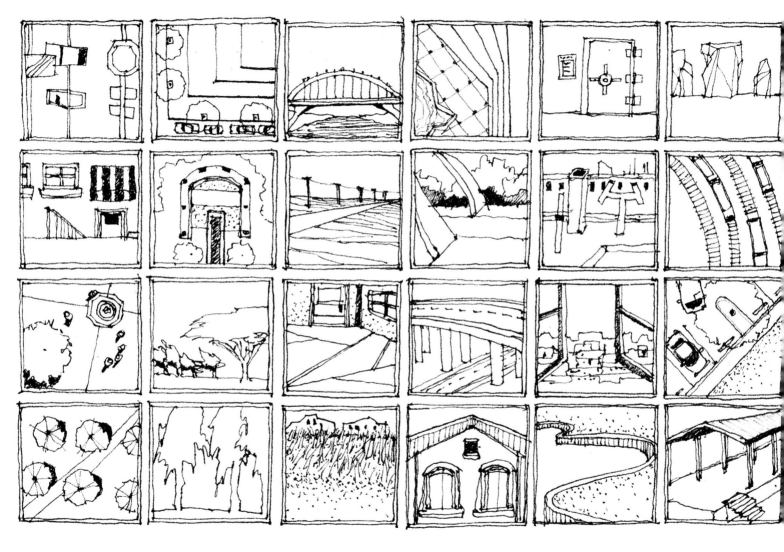

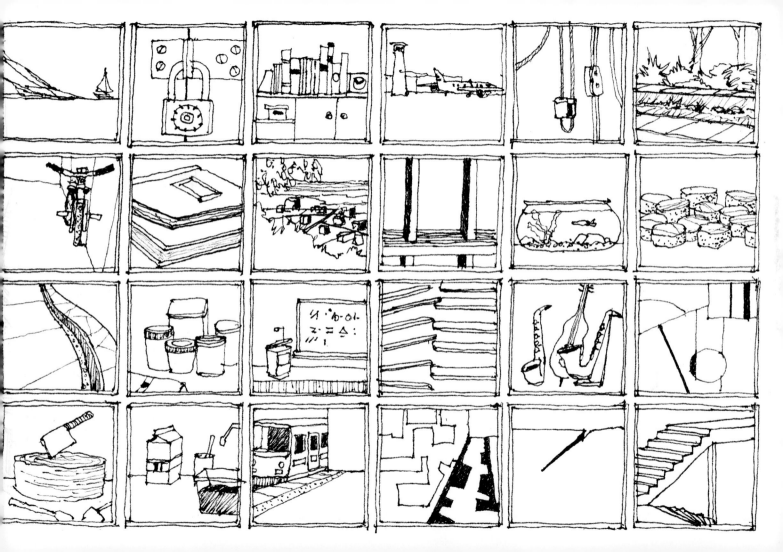

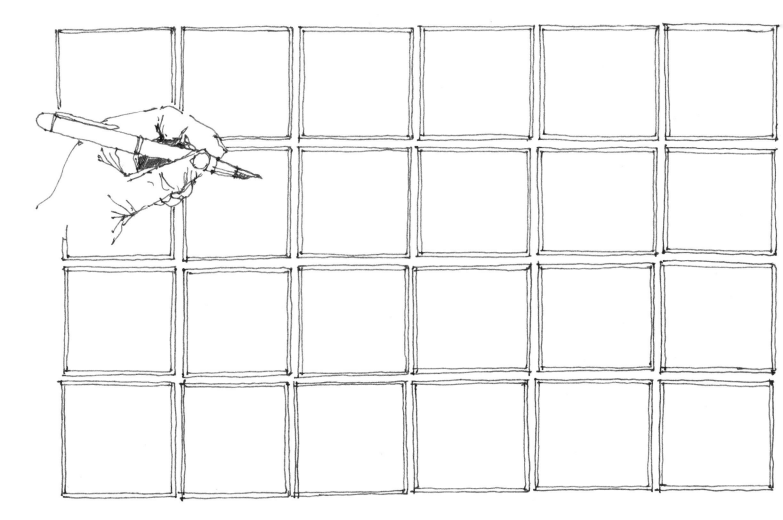

Acknowledgments

I would like to thank two particular teachers at the University of California Berkeley — Professor Chip Sullivan and Senior Lecturer Joe Slusky — for lighting the spark in my practice of art. I'm also grateful for Heather Clendenin, JC Miller, Anastasia Meadors, Ivan Trujillo, Rae Hagner, Heath Schenker, and Seth Wachtel who all gave me the opportunity to teach drawing, where I've learned as much from my students as they have from me. My appreciation goes out to publisher Gordon Goff and the staff at ORO Editions for believing in and supporting this book. And lastly, thanks to Kara, Casey, Kotaro, Lyra, Hannah, Nani, Natalie, Jake, Holly, Simone, Monique, and the rest of the crew at the Elmwood Cafe, for their years of serving me hot chocolate and providing a friendly atmosphere and seat at the counter for sketching and imagining.

Eddie Chau is a landscape architect, teacher, and artist, living in Albany, CA. He has taught freehand drawing and landscape graphics at UC Berkeley Extension, UC Davis, and the University of San Francisco. In addition to pen and ink, he enjoys painting and silverpoint mediums. This is his first book. He draws much better than he can write.

www.eclastudio.com

Publishers of Architecture, Art, and Design
Gordon Goff: Publisher

www.oroeditions.com
info@oroeditions.com

Published by ORO Editions

Graphic Design: Gordon Tillotson
Text and Images: Eddie Chau
Project Coordinator: Kirby Anderson and Jake Anderson

10 9 8 7 6 5 4 3 2 1 First Edition

Library of Congress data available upon request. World Rights: Available

ISBN: 978-1-940743-43-1

Color Separations and Printing: ORO Group Ltd.
Printed in China.

International Distribution: www.oroeditions.com/distribution

ORO Editions makes a continuous effort to minimize the overall carbon footprint of its publications. As part of this goal, ORO Editions, in association with Global ReLeaf, arranges to plant trees to replace those used in the manufacturing of the paper produced for its books. Global ReLeaf is an international campaign run by American Forests, one of the world's oldest nonprofit conservation organizations. Global ReLeaf is American Forests' education and action program that helps individuals, organizations, agencies, and corporations improve the local and global environment by planting and caring for trees.